IMAGES
of America

LIVINGSTON COUNTY

T0407601

On The Cover: After Salina McCoskrie Smith was widowed in 1866 with eight children to feed, she started her orchard in Monroe Township for income. In 1905, history repeated itself, and her widowed daughter Lora Webb and sons Arlie, Seth, and Buford relied on that same orchard of 1,000 fruit trees. Neighbors such as Myra Anderson and Lizzie Hamblin helped, and the fruit was sold in nearby towns. (Courtesy of the Roberts family.)

IMAGES
of America
LIVINGSTON COUNTY

Kirsten Mouton and
Brenda Anderson O'Halloran

ARCADIA
PUBLISHING

Copyright © 2023 by Kirsten Mouton and Brenda Anderson O'Halloran
ISBN 978-1-4671-6012-4

Published by Arcadia Publishing
Charleston, South Carolina

Printed in the United States of America

Library of Congress Control Number: 2023932715

For all general information, please contact Arcadia Publishing:
Telephone 843-853-2070
Fax 843-853-0044
E-mail sales@arcadiapublishing.com
For customer service and orders:
Toll-Free 1-888-313-2665

Visit us on the Internet at www.arcadiapublishing.com

To all those with a pioneering spirit.

CONTENTS

Acknowledgments

This book was possible due to the preservation efforts of both the Grand River Historical Society Museum and the Livingston County Library, which collect and maintain photography collections. A number of individuals and families shared personal pictures and information, which round out the book. Far more items were collected than could be used, but every one is treasured. The research was possible due to materials at the Livingston County Library, the *Constitution-Tribune* archives, Jim Stout's priceless Green Hills Pioneers website, the Missouri Secretary of State's digital heritage site, the State Historical Society of Missouri, and the US Library of Congress map collections. We are eternally grateful that Arcadia pursued our county so that this book could become a reality.

INTRODUCTION

Missouri Indians, as well as tribes from the north, resided and hunted in the Livingston County area prior to white traders and settlers. Native American villages were located one mile southwest and twelve miles north of Chillicothe, two miles east of Springhill, and ten miles east of Collier's Mill. Native Americans continued to use the area until about 1840.

Missouri began as part of the Louisiana Purchase of 1803–1805. In 1812, the districts within it became counties. Missouri became a state in 1821, with large counties and tracts identified as "Unattached" or "Indian Lands."

French hunters and trappers were the first European people into this area in the 1720s, with trading posts established by the early 1800s. These were abandoned due to difficulties with the northern tribes in this area.

Settlers came into the Livingston County area from southern counties on "honey hunts," forming bee-hunting trails in the fall of each year. The area was rich with honey, and wagons and barrels were filled to the brim with the sweet nectar. Samuel E. Todd was the first settler to make his homestead in the area, a mile and a half west of present-day Utica. The Mahaska band of Iowa tribe were his nearest neighbors, northeast of Chillicothe. Other settlers from Tennessee, Kentucky, Illinois, and Indiana began arriving in the early 1830s to what would become Livingston County.

As counties were created in Missouri, the population grew and boundaries changed. First, Howard County claimed the land that would become Livingston County. It became part of Ray County in 1820, and then Carroll County was formed in 1833 and took it. Livingston County was formed on January 6, 1837, including land that would become Grundy and Mercer Counties in 1841. The county was named after Edward Livingston, Andrew Jackson's secretary of state from 1831 to 1833.

Chillicothe was chosen as the county seat since it was within three miles of the center of the county. Clearly, it was known that Mercer and Grundy would eventually form separate counties. Chillicothe was ordered to be created in 1837 but not officially recognized until 1839. For a time, others were vying for Jamestown, or "Jimtown," to become the county seat, but John Graves, the owner of a hotel in Chillicothe, proved instrumental in ensuring Chillicothe was chosen.

Originally, Livingston County had only four townships: Shoal Creek, Indian Creek, Medicine Creek, and Grand River. The first store in the county opened in Navestown in the Indian Creek area. In 1839, the name for Medicine Creek was changed to Chillicothe, Indian Creek to Jackson, and Shoal Creek to Monroe. Chillicothe township held the county seat by the same name as well as Jamestown. Grand River township included the towns of Astoria, Bedford, and Grandville. Jackson township included Springhill, Muddy Lane, Shearwood, and Poosey. After Monroe township was split, creating a new Greene township with the town of Utica, the rest of Monroe held Austinville, Bluff City, Monroe Center, and later, Ludlow. Other townships were formed, including Blue Mound (1843), where the town of Dawn is located; Cream Ridge (1857), with Chula and Farmersville; Fairview (1867), with the town of Avalon; Mooresville (1866), with a town by the same name; Rich

Hill (1872), with Sturges and Coxville; Sampsel (1846), with the town of Sampsel; and Wheeling (1867), also with a town of the same name.

This book shows important aspects of community life prior to 1950. Pioneer life was hard and fraught with danger. Religion played an important role in the lives of most early settlers even though there were no churches or regular preachers until well after the establishment of the county. Proper church buildings began appearing in the 1850s in Chillicothe, and in the 1870s in most other communities.

Education of the youth was a challenge and started with hired teachers in homes as early as the 1840s. Several colleges in the county sprang up, mainly after the Civil War, but there are hints of earlier institutions.

As settlers arrived, they found an environment highly suitable for farming and animal husbandry. Slaves formed a small part of the farming workforce in the early days. Towns coalesced around important resources and later around railroad stops. Some settlements were fairly short-lived while others are still around today.

Throughout the history of Livingston County, the people have heeded the call to serve in the military. Men and women have participated in various ways on the front lines, teaching, and as support.

The square in the county seat was set aside from the beginning of the county as a central hub with a courthouse from 1841 to 1865 and again from 1914 to the present. Between those dates, it became Elm Park. Businesses strive to be on or near the square, as it is still an important focus for commerce.

Not every business in Chillicothe was on the square. A variety of service and supply providers spread all over the city, such as lumber yards, livery/transfer companies, and later, service stations. Locust Street was also a prime location for businesses, as Washington Street did not extend commercially south of Clay Street. Three city halls have stood just north of the square on Washington Street. Other government facilities were located on Locust Street south of the square. An industrial area formed near the Wabash Depot, and there were railroad division shops at the Milwaukee Depot prior to 1904.

The railroads were a huge boon to the region, bringing in people and supplies starting in the late 1850s. Many towns lived or died by the railroad. In fact, the railroad created several towns, such as Chula, Ludlow, Sampsel, and Sturges.

People took time to relax with various forms of entertainment, including basketball and baseball games and bowling tournaments. Weekends at the lake, parades, circuses, plays, and movies were all ways to unwind and enjoy life.

This book tells the story of the people who settled and lived in and grew the communities of Livingston County, Missouri, from a record-making police chief to a saloon keeper, a farmer to a librarian. Livingston County boasts a national highway president at the advent of the automobile age. The first loaf of bread was commercially sliced in Chillicothe because of an innovative baker and his partner. This is their story. This is our history.

One

County Communities

Numerous communities sprang up around resources like water and food sources as well as later railroad spurs. They did not all last. Austinville is one example of a town along a railroad spur forming with a post office, then disappearing as the spur became inactive. Other places that survive only on old maps include Norville, Granville, and Cavendish. Hickory nut harvesting was important to early communities like Mooresville, Sampsel, and Utica. Bee hunting was another activity that brought droves of people into the area in the fall of each year. In fact, it was honey hunting that enticed settlers into the area. Samuel E. Todd, the first white settler in the area in 1831, sowed the first crop of corn and created the first horse-drawn mill in the area. Other settlers in the early 1830s included Elisha Hereford east of Chillicothe, Reuben McCoskrie, John Austin, and Abe Bland in the southwestern portion of the county, and Levi Goben in Jackson Township. Close to 200 families, or 1,000 people, were in the area by 1836.

Pioneer Wesley Scott homesteaded in the Avalon area in 1845. After his death, the land was sold to David Carpenter, who had surveyor E.B. Parks lay out the town of Avalon on November 12, 1869. The main street boasted a post office, various shops, a hotel, a photographer, and a bank. Avalon had its own newspaper, the *Aurora*, by 1881. Notably, there were no saloons and no lawyers. (Courtesy of Grand River Historical Society Museum [GRHSM].)

The town of Avalon was named after Avallon in France. "Avallon" is a Celtic word for "apple tree." This ornate building can be seen in the Avalon main street photograph above. Two businesses were located here: a drugstore and a harness and furniture store. The upstairs may have been a residence. (Courtesy of Vicky England Elliott.)

John Maxwell Bowman started a steam flouring mill in Avalon around 1875. Bowman married Katherine Emery in 1878. This image of the mill dates to 1904. The raised loading dock made it easier to load heavy Daisy brand flour bags into wagons. The mill closed in 1908. There was no railroad in Avalon, so supplies had to be hauled by wagon to Chillicothe, Bedford, or Hale. (Courtesy of GRHSM.)

Originally named Leborn/Laborn, Bedford was rerecorded in 1839 and renamed. At its height, the town had two schools, two sawmills, a church, a bank, two hotels, and several factories. The general store of J.T. Snyder and Cleo Vanlandingham opened around 1912. It was considered a progressive store with many higher quality goods and name brands offered. This image dates to 1917–1918. The store closed in 1957. (Courtesy of Livingston County Library [LCL].)

Chula was incorporated on January 2, 1893. Mansur Street served as the main street and was home to stores, banks, the post office, and churches. The Chula Commercial Hotel is at right, next to Elijah Tredway's store, which sold silks and clothing around 1900. Farther down the street is J.B. Tracy's general merchandise store. (Courtesy of Vicky England Elliott.)

A flour mill was started in Chula in 1898 operating under the name of the Chula Milling Company. John William "Will" Jenkins was the owner of the mill for several years. In 1899, he married Martha Mace, and they made their home in Chula. Other owners of this steam mill included Gardener and Treadway and then R. Wallbrunn and Leavell. (Courtesy of GRHSM.)

Dawn had its biggest period of growth after the Civil War, with many businesses opening. The buildings on Main Street, pictured here, include stores for dry goods, stoves and tinware, furniture and undertaking, hardware, and implements. Both H. Bushnell and J. James were known to sell implements plus other merchandise, and the name "Peters" appears under the furniture and undertaking sign. (Courtesy of GRHSM.)

The "elegant" three-story frame Fisher House Hotel was built in 1884 for over $5,000 by druggist W.A. Fisher. He was a public-spirited man who also had a mercantile store during the growth spurt in Dawn after the Civil War. The large, airy rooms were well furnished. David E. Llewelyn managed the hotel. It was not in existence after 1918. (Courtesy of GRHSM.)

This general store in Sampsel was sold to George Allnutt and his wife, Florence, in 1914, having been previously owned by George and Perlee Wagner, then W.R. and Florence Walker. In the 1950s, George's grandson Bob Paschen worked in the store. This photograph was taken by Bob using a tripod. (Courtesy of Shanda Feeney and Jo Anne Frazier.)

Halloween in all the small towns of Livingston County brought out the pranksters, and many of their deeds were reported in the local papers. This c. 1900 photograph from Dawn illustrates how the streets were blocked—in this case, with a rail fence transferred from elsewhere, outbuildings moved, signs from businesses switched, and buggies placed in odd positions with wheels removed. Note the Sherwin-Williams paint sign. (Courtesy of GRHSM.)

Leo Moren, a prolific local photographer in the early 20th century, took this photograph on Main Street in Dawn of mail carriers David J. Evans and his nephew John Edward Evans standing with their team and buggy in front of the hardware store. The Evans men were part of the large Welsh community that had immigrated to the Dawn area of Livingston County, drawn by attractive farming opportunities. (Courtesy of GRHSM.)

Before 1900, John H. Shriner ran this blacksmith shop in Dawn. He was also known as a wagon and carriage maker. A Mr. Johnson once worked at a blacksmith shop at the west end of Main Street. Others known to work as blacksmiths in Dawn over the years include J.W. Hood, G.W. Fisk, Charles Bowen, and Charles Shinogle. (Courtesy of GRHSM.)

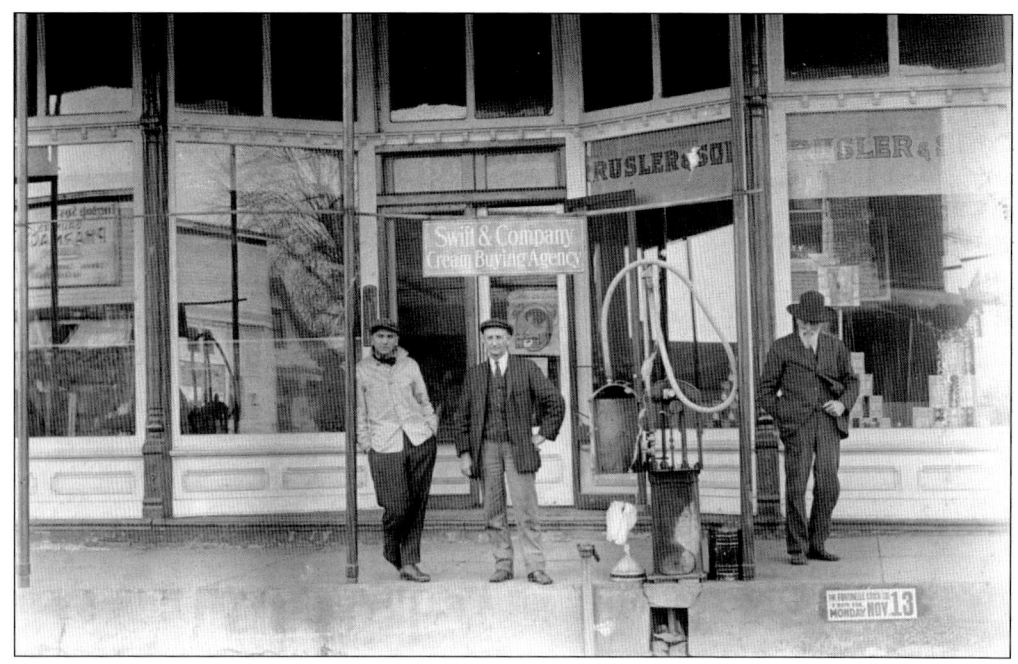

J.K. Rusler & Son General Merchandise store at Ludlow in 1917 had modern conveniences such as a private lighting plant, a metal floor to keep mice out of the flour bin, the latest devices for handling cream, and a large stock of goods. Out front at the curb was a Bowser gasoline pump for "autoists." Inside was a balcony for customers' comfort. (Courtesy of Deana Slater Sprouse.)

This is Main Street in Ludlow around 1930 looking south toward Shoal Creek, when the businesses included Ludlow National Bank, Hatchitt's and Robinson's groceries, Copple Oil, the Farmers Store of Inez Miller, Borrusch's Drug Store, Jess Ward's Garage, R. Lee Lumber Company, and an ice plant, among others. Saturday nights were the busiest time, when everyone came to town. (Courtesy of GRHSM.)

Dressed in postwar style, a young Grace Cruse and Clithro Anderson chat on Main Street in 1949 Ludlow outside Hatch's market, Ryan's Drugs, and Bowles' Station. Unseen across the street was the Ludlow National Bank. No one could have guessed that 35 years later, Clithro would be bank president, and Grace would write a popular book about the town. They have been married for over 70 years. (Courtesy of the Anderson family.)

These church ladies from Avalon are, from left to right, Mrs. R.T. Miller, Mrs. Marshall, Mary (Griggs) McDaneld, Nancy (Shields) Fair, Malinda "Linda" (Kenner) Linton, Mrs. Mary Ann (Linton) Fullerton, Mrs. Greener, and Mrs. Waitman. By the 1930s, only two churches were operating here, one of them in the old Avalon College. (Courtesy of GRHSM.)

In 1842, settlers found mineral springs northwest of Mooresville. E.J. Moore noticed that his hogs, after drinking that water, never contracted cholera. A 1901 analysis proved that the Mooresville Springs water contained minerals good for stomach and liver diseases. Dr. D.T. Fisk soon built a popular hotel and sanitarium that drew people from near and far as they took "the cure" in the hot and cold mineral baths. Drinking water bottled at the springs was sold until 1905. The popularity of mineral water had declined by 1925 when the hotel burned. The site became a much-used picnic grounds, while a few people still made use of the pump at the springs. (Both, courtesy of GRHSM.)

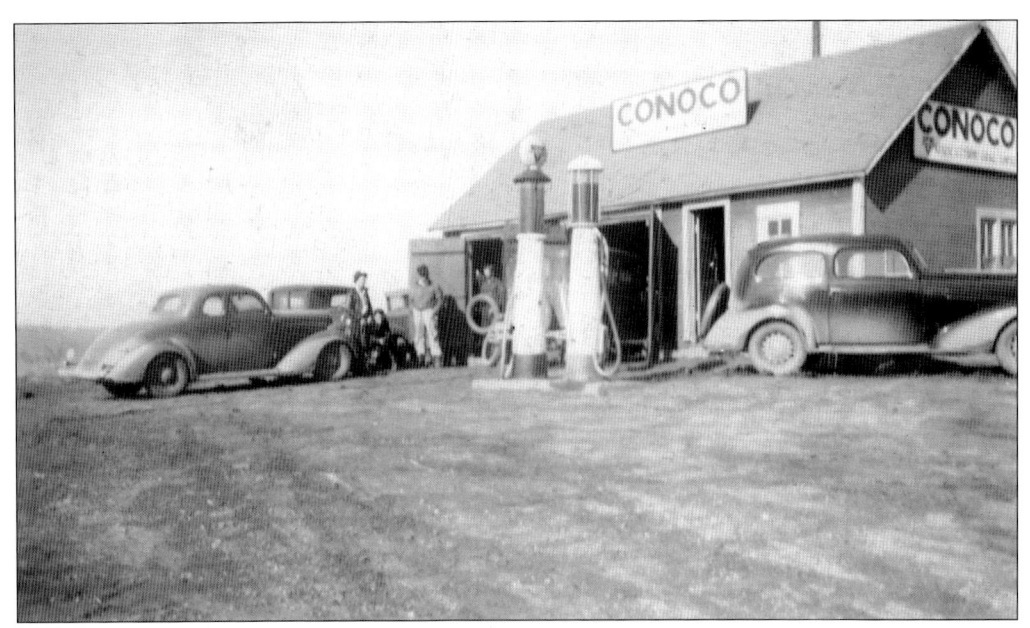

Blacksmith Corner, nine miles west of Chillicothe on Route 190, was a longtime landmark for giving directions in the northwest part of Livingston County. Long ago, a blacksmith shop stood where a road led south to Sampsel. In 1935, Wilbur Krause and Ira Wybrow built a filling station and garage at the corner. (Courtesy of Dean Brookshier and Donna Brookshier Good.)

Springhill was started by Jesse and Isabella Nave in 1836, with a name change in 1848. In 1912, brothers Alva and Charles Mast erected a two-story building in Springhill, seen here third from right with three women on the porch. The second floor was used for dances and plays, while the first floor housed their Mast Bros. store, where they sold general merchandise, including shoes. The building on the right is the Masonic temple, although it is likely the first floor was used as a storefront. The shed-like building between the two was used by the Mast brothers as a grain mill. (Courtesy of GRHSM.)

The Mast Bros. store doubled as a hangout for men in the community. The store closed in 1937 and the building was later torn down. Pictured here from left to right are Charles Mast, his son Paul, Alva Mast, and unidentified. (Courtesy of GRHSM.)

Ethel Lilly Boyle, affectionately known as "Pet" or "Aunt Pet," was a telephone exchange operator in 1908 in Springhill. She ran a rural switchboard in Livingston County from the home of her parents, James and Josephine Boyle. This was supposedly the first telephone line in the county. Pet and Thomas Lee Hicklin were married in January 1909. (Courtesy of GRHSM.)

The C.N. Boorn Lumber Yard in Sturges carried a large stock of lumber, hardware, implements, buggies, and wagons. This was housed in several buildings totaling 12,000 square feet of floor space. C.N. Boorn also founded and was president of the Peoples Exchange Bank in Sturges, and owned many acres of farmland. (Courtesy of GRHSM.)

Sturges was northeast of Chillicothe halfway to Chula, along a railroad line. Originally opened around 1887 by Hopper and Tracy, this business later became the C.N. Boorn general merchandise store and carried canned goods, flour, shoes, dry goods, clothing, notions, and Stetson hats, as well as produce, eggs, and butter. Charles Nelson Boorn ran his store for 38 years, retiring in 1923. (Courtesy of GRHSM.)

In 1908, B.J. Meek purchased land on the Grand River at Utica with the largest shale deposit in Missouri. There, he and his brother J.E. Meek built Meek Brick Company. A road to the plant, the first building for manufacturing, and a branch rail line were built. When the plant opened in 1910, four beehive kilns were used to fire the green brick. Standing in front of that first building below, from left to right, are manager J.E. Meek, two unidentified, Frank Lemon, unidentified, kiln builder Alf Meek, Bill Farner, unidentified, James "Oat" Peterie, Nathan Morris, Frank Morris, John Strickel, and John Krause. In 1913, the company became Shale Hill Brick and Tile. John Dailey was superintendent. In 1929, company president B.J. Meek sold controlling interest to the Dailey family. (Both, courtesy of Sherwood Patek family.)

An open-sided scove kiln was also constructed near the first building. Green brick was stacked inside, covered with wet clay, and dried with a wood fire. The view below shows the plant with many beehive kilns, brick stacks, and a railroad car awaiting loading. Shale Hill Brick, along with its shareholders and directors, went broke during the Great Depression. In 1935, C.H. Patek joined John Daily to reopen the business as Midland Brick and Tile Company. Patek's son Sherwood, an engineer who modernized the plant with machinery, joined the management in 1942. Sherwood won many industry awards for devising equipment. His brother Byron, a CPA, later joined the company. The Patek family sold to a British firm in 1988. (Both, courtesy of Sherwood Patek family.)

Wheeling was formed in 1865 by Henry Nay. This photograph shows a Grant Street hardware store on the left with a restaurant farther down. On the right are a drugstore and livery. The pile in the road may be brick to begin paving the street or erecting a building. At one time, Wheeling had two brick plants. (Courtesy of Vicky England Elliott.)

Dr. J.W. Trimble's Livery, Feed, Commission, and Sale Stable is seen on the main street in Wheeling. The watering trough was on the left side of the building; on the right side, it reads, "horses bought and sold." Next door was a drug store. (Courtesy of Vicky England Elliott.)

Two

CHURCHES

Religious life has always played an important role in Livingston County. The first pioneers held a simple service in a grove southwest of Utica. Early in county history there were traveling clergymen, and congregants would often meet in homes. Small towns throughout the state were strung together to form circuits or loops, with ministers visiting each in turn. As towns developed, store buildings were sometimes used for church meetings, and even a large room above a stable served as a church for a time. Congregations grew and proper church buildings sprouted up as early as the 1850s in Chillicothe. In the other communities in the county, formal church buildings appeared a bit later, in the 1870s–1890s. Benches were hard, and services were long. Denominations of the Christian faith are well represented by Baptists, Catholics, Episcopalians, Methodists, Presbyterians, and others. While members of the Jewish and Morman religions were present, they did not erect formal buildings for worship in the early days of our county. African Americans were not allowed to attend church independently until after the Civil War. They built two churches in Chillicothe in the late 1860s.

In 1868, the Bethel African Methodist Episcopal (AME) Church was built at 200 Henry Street in Chillicothe. Originally, the church was part of a circuit that included Utica, Trenton, Brookfield, Cameron, and Plattsburg. It was the first AME church north of the Missouri River. A cemetery was acquired by the early 1900s and is referred to as the North Cemetery. (Courtesy of LCL.)

The Sunday school of Bethel Methodist Episcopal Church South heads off on a wagon to their annual picnic in a grove. From 1868 to 1951, Bethel served mostly families of early settlers from Tennessee living in Monroe Township north of Ludlow. The historic cemetery contains the old graves of the Anderson, Austin, Bryan, Culling, Glaze, Lyday, Sidden, and Truitt families. (Courtesy of Sidden family collection.)

A group from a number of regional congregations met on March 17, 1895, to form the Chula Baptist Church. A building was erected by Rev. S.M. Brown on two lots on Main Street, with dedication services taking place on August 8, 1896. The church was remodeled in 1930 with a basement added. (Courtesy of GRHSM.)

Originally, Dawn had only one frame church, built in 1872 by the Presbyterians for $2,500. Several denominations held services there and combined for one large, well-attended Sunday school. By 1920, there were Congregational, Presbyterian, and Methodist churches, which in 1927 joined together as the Federated Church to meet in a one-time opera house. Dawn Baptist Church was built from two country churches that moved into town in 1947. (Courtesy of GRHSM.)

Chillicothe's First Christian Church met in the brick courthouse in the square around 1844. They erected a church at the northwest corner of Washington and Clay Streets in 1850. By 1889, the congregation had grown and a new church was built at the southwest corner of Cherry and Jackson Streets. In 1926, the second church was razed, and a new building, pictured here, was erected. (Courtesy of GRHSM.)

The mostly Irish Catholic community in Hogan's Settlement, 11 miles northeast of Chillicothe, established and built St. Patrick's church in 1884, then changed the name of the community to Leopolis in honor of Pope Leo XIII. Leopolis Cemetery sits adjacent to St. Patrick's. The Sisters of Mercy had a convent and school at Leopolis from 1890 to 1898. The church was closed in 1989. (Courtesy of GRHSM.)

The Grace Episcopal Church in Chillicothe dates to 1857, with a small congregation that was part of a circuit with Utica and Brunswick. Early services were held in the Platter Hall above a livery on Locust Street. In 1869, plans were made to build a church on Elm Street. This was the first prefabricated church building in the Diocese of West Missouri and was also one of the earliest examples of a prefabricated building. The beams, posts, and wainscoting were shipped from St. Louis by wagon. The cornerstone was laid in August 1869 by Missouri bishop Robertson, who consecrated the church in May 1876. The church included painted and stained-glass windows in brilliant colors. Early church members included Andrew and Hannah Platter, Capt. William Norville, E.H. Lingo, William Talle, W.L. Harding, General Hammond, and Andrew and Martha Leeper. (Both, courtesy of Grace Episcopal Church.)

St. Joseph's Catholic Church was built in 1895 after Bishop Burke formed a second parish in Chillicothe south of Jackson Street. The church and rectory were built adjacent to the vacant site of the first St. Columban Church, south of the railroad tracks. In 1956, St. Joseph's was closed. The two congregations were united and helped fund and build Bishop Hogan Memorial School. (Courtesy of LCL.)

St. Joseph's Church was founded by Fr. Edward J. Sheehey in 1877 to serve the Catholic families of Utica. Flavian Bonderer was the chief builder. The Utica church closed in 1959 after celebrating its diamond jubilee in 1952. Names of the congregation included Anderson, Potts, Murphy, Braden, Culling, Sprague, Merriman, and Bonderer. (Courtesy of LCL.)

GREETINGS FROM CHILLICOTHE, MO. ST COLUMBAN'S CHURCH & FRANCISCAN RESIDENCE.

St. Columban Catholic Church parish was established in Chillicothe in 1857 by the missionary priest Father John Hogan, later bishop of St. Joseph and of Kansas City. In 1879, German brother Adrian Wewer, a noted Franciscan architect, was commissioned to design and build the new church. He returned to Chillicothe in 1892 to design and build the large Franciscan monastery, now the rectory, and to add the sanctuary and transepts to the church. Recent renovations returned the church and rectory to their historic splendor and allow them to be used as intended, rare for such old buildings. (Both, courtesy of LCL.)

Interior St. Columban's Church, Chillicothe, Mo. 18164

Lewis Collier purchased land on Medicine Creek east of Chillicothe and built Collier's Mill in 1853 where the Wheeling Road crossed the creek. The stream below the dam became a popular place for fishing, swimming, baptisms, picnics, and Sunday school outings. This photograph was taken by Emma Dimitt Botts on a snowy day in March 1897 when Luetta Watson Mikels, dressed in white, was baptized by Rev. David Lyon of the Wheeling Christian Church. Ice was cut to allow submersion. George R. Dimitt stands on the bank holding the team of horses and Jessie Dimitt Walkup, who sang that day, is among the other witnesses. Lewis Collier's son Luther T. Collier was a Chillicothe attorney, a Missouri state representative, on the University of Missouri Board of Curators, and known for his historical articles about Livingston County. (Courtesy of GRHSM.)

Three

EDUCATION

The issue of educating children was taken up quickly by local pioneers settling the area. In 1845, itinerant teachers charged $3.11 per student. Parents subscribed to the teacher and furnished a room for instruction, often in their homes. Mostly English was taught. In 1841, the second courthouse was donated to be the first school in Chillicothe. In rural areas, schoolhouses were built a bit later. There were many rural schools as small communities developed and consolidated the teaching of their children. Over time, these schools grew, merged, or were sometimes abandoned.

There are hints of early institutions like the Beecham Academy, where a Mrs. Slack originally taught music in Chillicothe in the late 1850s, as well as the Armstrong and Bennet Academy in the 1870s for dentistry, but very little is known about these schools.

Larger institutions developed in a few places such as Chillicothe and Avalon well after the Civil War and the completion of the rail systems. The Missouri Industrial Home for Girls, Avalon College, and Chillicothe Normal School and Business Institute (later the Chillicothe Business College) all started around the 1880s to 1890, with Maupin College starting around 1900.

Once the Civil War was over and blacks were freed, they were legally allowed to attend school. Segregation existed for a long time after, so blacks were taught in their own facilities.

The Avalon Academy was started in 1869 by the United Brethren, opening to students in 1873. This became Avalon College in 1881, with four classrooms on the first floor and the chapel/auditorium and another multi-purpose room on the second. With a revamped curriculum, attendance nearly doubled, and in 1883, a third story was added. Around 1890, the college was sold to the Presbyterians, who ran it until 1900. (Courtesy of GRHSM.)

Avalon College's descriptive geography class poses on October 17, 1894, with several *Butler's Complete Geography* books. This photograph came from Frances Lee Rawlins, whose father, R.L. Rawlins, attended the college. Robert Lee Rawlins is in the third row, third from the left. It is not known where this photograph was taken, as Avalon College had brick walls, not limestone blocks. (Courtesy of GRHSM.)

There has been a succession of Blue Mound Schools since 1851. The school built in 1875 was destroyed in the Great Tornado of 1883 and rebuilt. In 1911, the Blue Mound District voted to build a new school with a library that these children attended in 1938. In 1957, the Blue Mound School District was split between Chillicothe and Tina-Avalon, and the building was sold at a public auction. (Courtesy of LCL.)

Central School in Chillicothe, to the left in this photograph, was designed in 1875 by St. Louis architect Charles Clarke. All grades from all wards attended here. The high school used the third floor, while the Hazelton Library was in the basement. In 1901, a new high school was completed south of Central with a gym on the third floor and a 250-seat auditorium on the first floor. (Courtesy of LCL.)

The classes of 1907, 1908, 1909, and presumably 1910 to the far left posed for a photograph in front of the new high school with the old Central School in the background. In 1907, there were six teachers and a librarian at the high school. Subjects included math, English, German, Latin, history, and science. The senior class president was Henry Platter. (Courtesy of LCL.)

In 1923, a stairway collapsed in the old Central grade school. Pressure from parents forced a bond issue to build a new school for student safety. Amid controversy over various building sites, the school board chose a location on West Calhoun Street and hired local architect R. Warren Roberts to design this building, which opened for classes in September 1924 and was used until 2000. (Courtesy of LCL.)

Nancy Chapman was a popular teacher at Chillicothe High School. She died unexpectedly on Saturday, April 23, 1938, at the age of 33. She had been teaching her English, sociology, and economics classes that previous Monday. Her memorial service was held in the high school auditorium with over 1,100 people coming to pay their last respects. Student pallbearers included Ronald Somerville, Fred Schaffer Jr., Nolan Chapman, and Jack Reynolds. (Courtesy of GRHSM.)

The Chillicothe Normal School was one of the best-equipped schools in the country. Inside the classroom building shown here were 250 typewriters, over 200 telegraphy instruments, 7 posting machines, 4 calculators, and a large number of Dictaphones. The average daily attendance in 1925 was 1,200–1,500 students. On March 29, 1925, a fire quickly engulfed the tall, brick classroom building. It was a complete loss. (Courtesy of GRHSM.)

The Chillicothe Business College was started by Allen Moore in 1890 under the name of the Chillicothe Normal School and Business Institute. Around 1905, it boasted "Seven Great Colleges": Normal School, Commercial College, Shorthand College, Typewriting College, Telegraphy College, Musical Conservatory, and Pen Art. This photograph shows the Pen Art class in 1905. John D. Rice was the associate principal of the Commercial College and Penmanship. (Courtesy of LCL.)

The Chillicothe Business College held an annual homecoming parade in November. The day also included a pep meeting, a football game that they usually won, a bonfire, and a homecoming ball. This parade float in 1945 celebrates the raising of the flag on Iwo Jima. A bus depot is visible at the corner of Washington and Jackson Streets. (Courtesy of GRHSM.)

Before the town of Chula was established in 1885, a one-room frame school stood in the center of the community. It was replaced in 1894 with the two-room frame building with a bell tower seen here, and the school was organized by grades through ninth. A third classroom was added in 1904. By 1937, a full four-year high school course was added, and the library boasted 2,000 volumes. (Courtesy of GRHSM.)

In 1927, Chillicothe Schools' supervisor of music J.E. Dillinger started the 15-piece Garrison School Band, as seen in this 1928 image with Prof. E.O. Boon, school principal and band booster. The band relied on community fundraisers and benefits such as minstrel shows, dances, and concerts and was showcased at Masonic and political events and performed with other orchestras, receiving high praise. (Courtesy of GRHSM.)

From a one-room building on Conn Street with over 100 students, to the 1890s five-room school pictured here, followed by the 1953 Kindergarten–12th grade Garrison School at 209 Henry Street, local black children were segregated and taught with second-hand materials by powerful educators—teachers named John White, Eileen Price-Scholls, Virgil Williams, Annabelle Banks, H.C. Madison, Alonzo Redmon, Ella January, and Jasper Simmons. This school was named after abolitionist William Lloyd Garrison. (Courtesy of GRHSM.)

The State Industrial Home for Girls opened on January 22, 1889, in Chillicothe. The girls received lessons in all kinds of practical topics while at school on the first floor of the chapel. They also had an orchestra that played in town and practiced in the chapel. Religious services were held on the second floor. The Missouri Cottage dormitory to the southeast of the chapel was added in 1895. (Courtesy of LCL.)

Slack Cottage at the Industrial Home for Girls opened in 1902. Common rooms for eating, laundry, offices, and classes were on the first floor, with bedrooms above. Isabella Slack was appointed to the governing board in 1889 by Governor Marmaduke. She was remembered as a woman with "business instinct." To the right, part of Marmaduke cottage is visible, as well as the heating plant with an 80-foot chimney. (Courtesy of LCL.)

The Missouri State Industrial Home for Girls included a musical component in its lessons. The school had an all-girl orchestra since at least 1908 that was well received by the public, with performances at the school as well as at various venues around the county. The Ladies Eight-Piece Orchestra provided the Majestic Theatre with music for its silent movies. (Courtesy of GRHSM.)

St. Joseph's Academy provided a Catholic education at Ninth and Trenton Streets from 1872 until 1969. Operated first by the Sisters of St. Joseph of Carondelet, and after 1935 by the Sisters of St. Francis, the school moved to the adjacent St. Columban school building in 1957 to make space for Bishop Hogan School. (Courtesy of LCL.)

Known as Ludlow Public School, this building housed 12 grades in four classrooms and a study hall/assembly room. Boys and girls used separate staircases, floors were oiled wood, and coal dust coated desktops in winter. In summer, the iron fire escape was a place for kids to sneak cigarettes. The toilets were outdoors. The class of 1951 was the last to graduate before the schools in southwest Livingston County consolidated. (Courtesy of GRHSM.)

School began in Utica in 1853. This building was constructed in 1867 on a lot originally reserved for a courthouse. In 1900, Utica School aimed to graduate students ready for college or normal school. In 1915, it was deemed "the finest school in Livingston County." The building and the school records burned in 1944. Utica also maintained an outstanding school for black students in those days of segregation. (Courtesy of Rosina and George Harter.)

When this picture was taken in 1894, Vaughn School was known for its well-attended Saturday-night literary presentations of music, readings, and debates. The school, four miles west of Avalon, had so many students attending that classes were held during lunch and after school. In the 1930s, hundreds attended the popular Vaughn School reunions, including author Olive Rambo Cook, who lived in the area as a child. (Courtesy of LCL.)

The early settlers in the Wheeling area built a log school in 1859. It served until a neat frame schoolhouse was built on the northwest corner of State and South Second Streets in 1867. The third Wheeling schoolhouse, pictured here, was built in 1882 at the northwest corner of North Fourth and Grant Streets and was replaced by a new brick building in 1920. (Courtesy of GRHSM.)

Wheeling High School was built in 1920 when a four-year program was added. A 1954 addition brought a gymnasium, stage with dressing room, office, kitchen, and modern restrooms. A dining hall and an industrial arts shop were added in 1972. The class of 1992 held the final graduation. This school continues to be remembered for its powerhouse basketball teams of the 1920s and 1970s. (Courtesy of Dorothy Switzer Spidle.)

Four

FARMS

The earliest farming settlements were made in the timber areas near a water source. Once the land was cleared, the ground in timbered areas farmed more easily than in prairie areas. Much of the land is highly suitable for farming, with rich soil extending down about 15 inches. As settlements grew, people pooled their resources to improve and farm the land. It was a community effort. In the 1840s–1850s, labor for farming was cheap to hire. Slavery was part of some of the early farms in Livingston County, especially for those moving in from Kentucky and Virginia. In 1860, less than 200 families had slave labor, with slaves making up one-tenth of the total county population. In 1912, Missouri ranked third in the nation for its quantity of corn and fifth for wheat. Livingston County's main crop was corn, followed by wheat and oats. Farms also included poultry, eggs, cattle, dairy, hogs, horses, mules, and bees. Cattle breeds in the early part of the 20th century included Angus, Hereford, Shorthorns, and Galloways. Percheron draft horses were also popular at that time. Apple orchards also extended across the county. Just over half the land in the county was being farmed as of 1916. In the 1930s, the average farm size was 141.7 acres.

Judge Thomas and Mary Hutchison came to Livingston County in 1840. Their homestead was completed in 1846, with brick walls over a foot thick, surrounded by black locust trees on 1,000 acres. They had nine children: John, Lucy, William, Eliza, Mary, Thomas, George, Charles, and Jeremiah. Jeremiah served in the Civil War as a lieutenant under General Slack for a time. A large storm damaged one of Jeremiah's auxiliary buildings. This outbuilding replaced an earlier cabin where former slave Logan Hutchison had lived. Jeremiah's son William Clayton "Clate" Hutchison died in 1947 in the same house in which he was born, the home his grandfather built. (Both, courtesy of LCL.)

Allen Moore Sr. came to Chillicothe in 1890, having run the normal school in Stanberry, Missouri, as well as the one in Springfield. In 1883, he married Emma Dryden. They made their home on North Monroe Street and had Shetland ponies and Jersey cows on their farm outside of Mooresville. Their son George had a favorite pony named Arnold. This photograph was taken on December 20, 1903. (Courtesy of LCL.)

Elora Austin Sidden was descended from the Austin, Bryan, and Lyday families, who were among the first settlers to arrive in Livingston County in 1833. In about 1915, she lived in Section 32, Mooresville Township with her son David "Crockett" Sidden; his wife, Mamie Malina Culling; their children Leland, George, and Vesta; and dog Gunner. Back then, it was common for multiple generations to live together. (Courtesy of the Sidden family.)

Nadine Lavilla Dome, born in 1901 in Utica, is seen here with her dog Gus on the 96-acre farm of her parents, Ralph and Rosina Dome. The farm was inherited from the Baltis side of the family and passed down to Nadine's only child, Sue Rose Mounce Harter. Nadine married Earl Mounce in 1923. Nadine's granddaughter Rosina Harter now lives on the property. (Courtesy of Rosina and George Harter.)

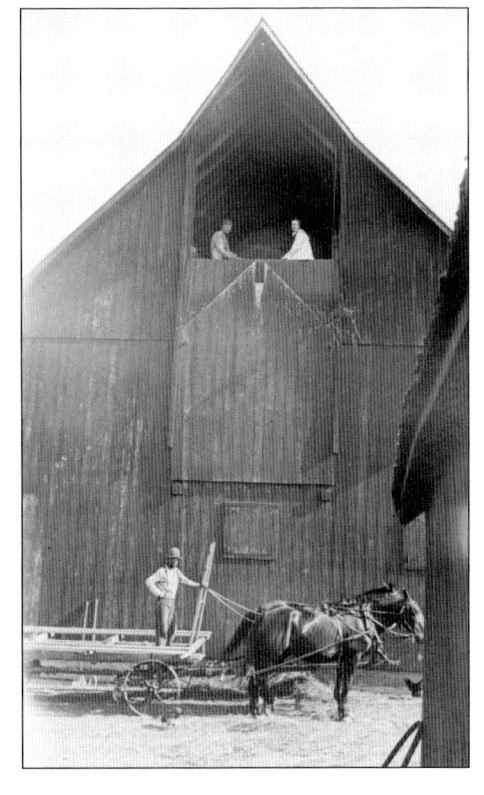

Ralph Dome stands in a wagon in front of his barn erected in 1904. The lumber was hand-hewn and then assembled with wooden pegs by two deaf Civil War veterans, Bert McCoy and Oral Lemon. The University of Missouri used this as a model barn, bringing students out to see it. The animal pens in the back are at a lower level on the other side. (Courtesy of Rosina and George Harter.)

In 1833, Joseph Cox settled in Livingston County on property still owned by the family today. His home served as the courthouse for the first term of Livingston County Court on April 6, 1837, when judges Joseph Cox, William Martin, and Reuben McCoskrie divided the new county into four townships—Shoal Creek, Indian Creek, Medicine Creek, and Grand River. Cox left for Texas in 1851. Four of his sons remained here. (Courtesy of GRHSM.)

Isom James Cox was one of the earliest settlers in Livingston County. Still healthy and working at age 90 in 1905, he farmed on family land. He was a son of Joseph Cox. Few people know Isom served as a guide for the militia in the 1836 Heatherly War, when a family of desperadoes falsely initiated an Indian war in the county. (Courtesy of GRHSM.)

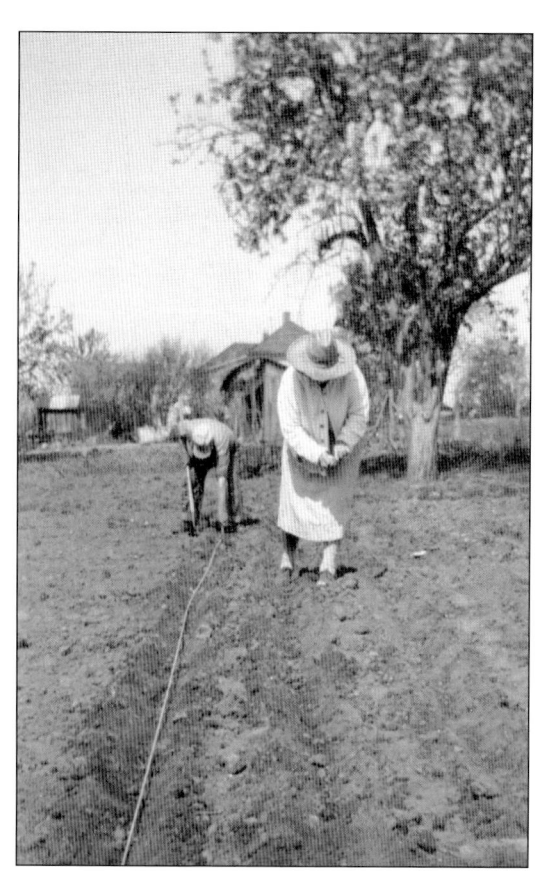

Grover Thomas Gann and his wife, Mabelle Hoerath Gann, pictured about 1930, planted a large garden on their farm near Sampsel to supply much of their food, like many people at that time. The Ganns and their descendants are related to the Hicks, Minnick, Mast, Dryden, and Brookshier families, all early pioneer settlers in Livingston County. (Courtesy of Dean Brookshier and Donna Brookshier Good.)

About 1925, Marie Gann Dryden of Sampsel poses in a goat cart. The popular carts were seen in parades, at amusement parks, and as props used by traveling photographers. The local newspaper frequently featured stories of goat carts, including the time in 1936 when Dave "Paddlefoot" Martin of Chillicothe made a three-week trip home from Joplin in a two-goat cart. (Courtesy of Dean Brookshier and Donna Brookshier Good.)

Eliza Jane Davis married Edmund Rumney Ott in Livingston County in 1872. She and her family lived in Chillicothe at 329 Dickinson Street in 1880. By 1917, they had moved to 1302 Clay Street. Though "city dwellers," they enjoyed time on the farm with neighbors and friends. This photograph shows her as "Grandma Ott." (Courtesy of LCL.)

Chancie Brookshier and son Russell Dean Brookshier tried sheep riding on their farm near Sampsel around 1930, posing in front of what is thought to be a corn crib and a grove of fruit trees. Farm children through the years have been challenged to ride sheep, and this evolved into children's rodeo events called "mutton busting." (Courtesy of Dean Brookshier and Donna Brookshier Good.)

Ralph Loomis Dome farmed this field with his workhorses Babe, Star, and another. At the turn of the 20th century, neighbors owned different pieces of farm equipment and shared in the working of all their neighbor's farms. Charlie White, a black farmer and property owner in Utica, offered his labor in lieu of equipment. (Courtesy of Rosina and George Harter.)

James Nelson Roberts was a self-made and prosperous farmer from Mooresville. He used progressive methods to farm his large tracts of grain fields including this modern steam engine. Additionally, Roberts raised stock and ran a sawmill. He bought his first 60-acre farm in 1881 with money earned selling US maps, and died in 1938 with 1,000 acres in Mooresville and Sampsel Townships. (Courtesy of the Roberts family.)

Five

RAILROADS

Early settlers navigated the area by horseback, wagon, and waterways. Once the railroad entered the picture, things really began to change. Towns formed along the lines and spurs, such as Austinville, Granville, Sturges, and Castile. The influx of people, visitors, and supplies was a real stimulus to the county. If a spur became discontinued, the town dried up.

The earliest train in the area was the Hannibal to St. Joseph. A lot of towns wanted to be included in the line, with negotiations starting in 1846. The Missouri legislature passed a charter in February 1847. Counties and the state government had to work together and pitch in to make the rail line a reality. A convention was held in Chillicothe on June 2, 1847, to discuss the matter and refine the actions to be taken, with men from all over northern Missouri attending. On November 3, 1851, ground was officially broken in Hannibal. Livingston County's representative, W.C. Samuel, was present. Work on the western end of the line began in 1857. The rail line was finally finished a little east of Chillicothe on February 13, 1859. Later, it changed hands to the Burlington Railroad.

A northeast-southwest line called the Chicago, Milwaukee & St. Paul was established in 1887. In 1904, that rail division was removed to Laredo. The Chillicothe & Brunswick line ran between those two towns starting in 1870.

A few other rail lines were planned for Livingston County but never materialized, including the Chicago & Southwestern; Ottumwa, Chillicothe & Lexington; and the Chillicothe & Des Moines.

Gus Stoll's 42-yoke ox team was doing pre-construction street work for the Wabash Depot. The oxen are pulling a train car probably packed with building materials. Stoll is third from left. The earliest depot was just south of First and Slack Streets, east of Vine Street. Telegraph poles are visible; the first message was sent on July 4, 1859, from Hannibal to St. Joseph. (Courtesy of LCL.)

A depot was built on the Wabash Railroad a mile north of Bedford in the 1870s. From there, a horse-drawn railway transported passengers into town and was used daily by workers commuting from Chillicothe to the Bedford tobacco factories. In 1882, the Bedford depot building was moved four miles down the tracks to Fountain Grove, unfortunately for Bedford. (Courtesy of LCL.)

In the Great Flood of 1909, two roaring walls of water nine feet high rushed down the Grand River basin, destroying bridges, railroad embankments, homes, and farm fields, spreading six miles wide. Police chief Maurice Dorney phoned out warnings at 2:00 a.m. on July 6. Phil Hartman, a local merchant, rallied citizens to begin rescue work. Due to the early warning, the death toll was limited to three. In Jackson Township, the entire Charles Lamp family went missing, but their house was located. By the next morning, everyone had been found and rescued, including the Lamps, and water levels began to lower. Damage was estimated at $2.5 million in 1909 dollars (about $81.55 million today.) Pictured here are spectators investigating the Chicago, Burlington, & Quincy Railroad's great loss. (Both, courtesy of GRHSM.)

Telegraph poles ran alongside rail tracks, allowing better communication via Morse code. In 1910, the Chicago, Burlington, & Quincy Railroad became the first company to print messages onto paper. Telegraph workers used "climbers" on their lower legs to scale telegraph poles to string lines and make repairs. Billy Ott, son of Edmund and Eliza Ott, is seen here fifth from left. (Courtesy of LCL.)

Chula arose with the building of the Chicago, Milwaukee, & St. Paul Railroad in 1886. The depot was built in 1891 and is seen here in 1909. Four passenger trains stopped daily. Telegraphs were received and sent from here. In 1922, Chula was the second busiest shipping point between Kansas City and Ottumwa, Iowa. Known depot agents included Billy Wright, Walter Carson, Shorty Phillips, and Russ Adkins. (Courtesy of GRHSM.)

FIRST TRAIN IN CHULA, MO. AFTER FLOOD. JULY-09

The Great Flood of July 1909 washed away many miles of railroad embankments, buckled tracks, and carried away bridges, steel rails, and ties, as nine-foot walls of water roared down both forks of the Grand River. Transportation was impossible for days. The first train to reach Chula after the flood is pictured here at the depot with travelers thought to be flood refugees. (Courtesy of GRHSM.)

When the Milwaukee Railroad was located a mile south of Monroe Center in 1887, existing buildings were moved there, creating the new town of Ludlow around the depot. Town lawyer Marvin Pollard doubled as train agent. Residents could take a train to Chillicothe or Kansas City and return the same day. (Courtesy of GRHSM.)

Seen here around 1890, the eastern end of Webster Street encompassed the Chicago, Milwaukee, & St. Paul depot, completed in 1887, and the Sherman House. Prior to 1904, this depot, along with the Wabash Depot, saw 27 passenger trains a day. From about 1896 to the 1920s, the hotel was known as the Phillips Hotel, run by David and Lucy Phillips. (Courtesy of GRHSM.)

The Chicago, Milwaukee, & St. Paul Railroad located its division shop with work crews on the east side of Chillicothe, sparking prosperity and improving that part of town where the train families lived. Pictured here, the roundhouse at Jackson Street had stalls where several locomotives could be serviced and turned around on the turntable out front. (Courtesy of Vicky England Elliott.)

The plat for Sampsel was created on July 31, 1871, by John and Elizabeth Whitaker, James Britton of St Louis, and William and Emily Whitaker of Livingston County. The town was named for a railroad employee, J.E. Sampsel. The Brunswick–Chillicothe–Omaha railroad started construction in 1867 and was completed in 1871. The depot was also completed in 1871 and sat on the north side of town, north of the tracks. Directly east of the depot was the grain elevator run by the Scruby family and stockyards for shipping grain, cattle, and hogs by J.E. Raulie. Below is the home of Wilkie and Bernie Owen north of the depot. (Both, courtesy of Shanda Feeney and Jo Ann Frazier.)

STURGES DEPOT.

The town of Sturges, named after a railroad official, was established by the Chicago, Milwaukee, & St. Paul Railroad in 1887. Land was purchased from the Hopper and Kappas families. The first Sturges Depot, pictured here, included an interior waiting room, a Western Union Telegraph office, a freight room, and a second-floor apartment for the rail agent. (Courtesy of GRHSM.)

The first two depots at Utica were burned by local citizens who thought a mile west of town was too far. In 1913, the third depot (in a new location) also burned "accidentally." The fourth depot, with its brick platform seen here, was used until trains quit stopping at Utica in the 1940s. (Courtesy of LCL.)

Several train derailments took place on the Burlington tracks west of Utica over the years. One sensational wreck occurred in October 1903 with a head-on collision of two trains, allegedly caused by a missing semaphore signal to order a stop. The force of the crash sent three engines and three freight cars into the ditch as the crew jumped off to avoid death. The brakeman ran into town to call for help. Crowds of curious folks visited the scene, and a train car full of railroad officials arrived to investigate possible employee error. No charges were filed. These pictures of the scene were found in the collections of the Dome and Mounce families, who were no doubt among the spectators. (Both, courtesy of Rosina and George Harter.)

This is the north side of the Wabash Depot area. Joe Zweifel owned the small white store on the corner of Elm and First Streets; the sign out front reads "OK Barber Shop." To the north of this, across First Street at Elm Street, is the only known photograph of the Chillicothe Baking Company, built in 1921, where the first loaf of bread was sliced commercially in 1928 by Frank Bench and Otto Rohwedder. Behind the bakery to the right is the turret of a large Victorian house built by S. Norris in 1895. Across Elm Street from the baking company is the Tootle-Campbell Shirt and Overall factory, erected around 1909, a precursor to Boss Manufacturing. Crookshanks Bakery, built in about 1922, is east (right) of that plant. At far right is Producers Creamery, designed by R. Warren Roberts in 1928. (Courtesy of GRHSM.)

Six

AROUND THE SQUARE

As the town of Chillicothe was laid out in 1837, a public square was set aside bounded by Washington Street on the west, Webster Street on the north, Locust Street on the east, and Jackson Street on the south. This was the main focus of commerce for the town. In 1838, a public well was dug near the southwest corner. The second county courthouse was built in 1841, set in the center of the square. After the Civil War, it was torn down and some of the brick was used to build new businesses on the east side of the square.

After the removal of the second courthouse, the square became a thicket of black locust trees, with cattle and hogs running loose. In 1877, dentist and inventor Dr. Jacob Greene transformed it into a beautiful park. He received permission to remove the trees and bushes and replaced them with maple and elm trees. This was known as Elm Park for many years. In 1914, with the construction of a new courthouse, many of the park's trees had to be removed. The square remains a center of commerce to this day.

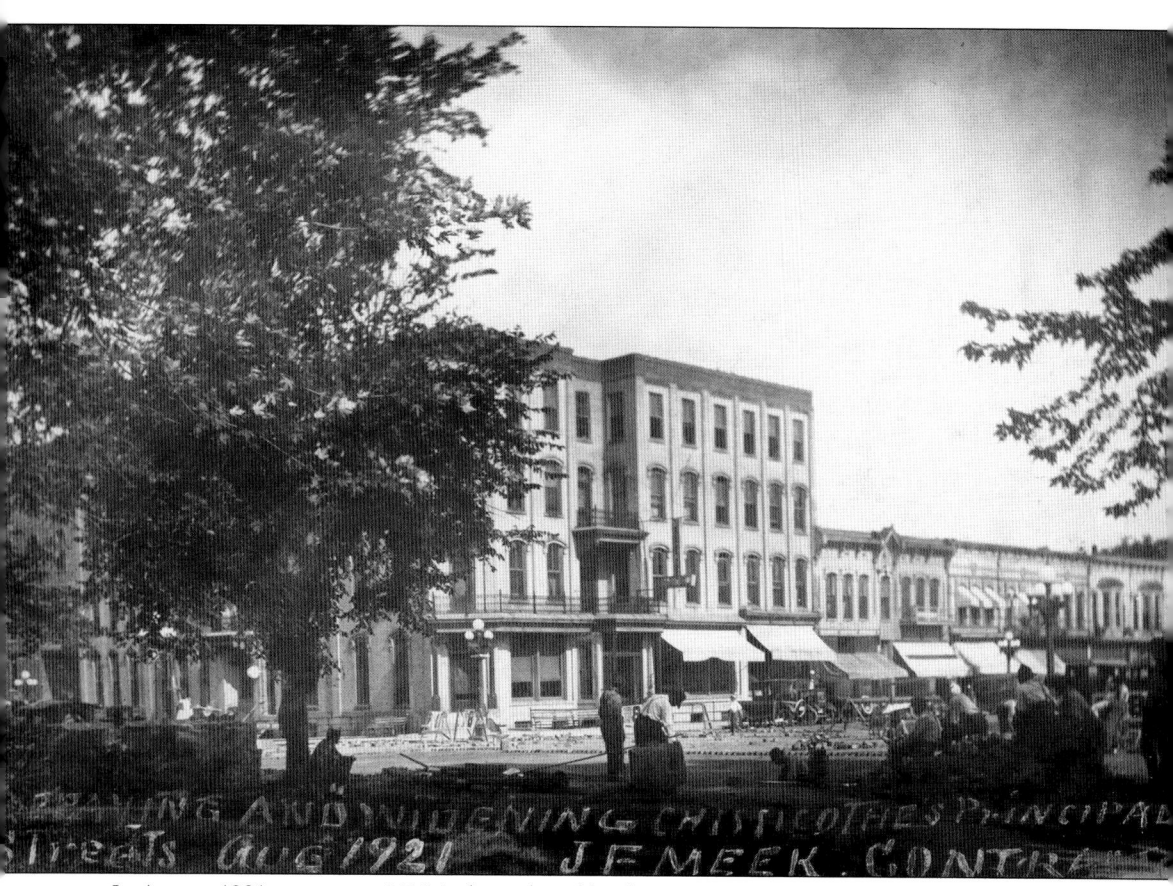

In August 1921, contractor J.F. Meek was hired by the city to repave and widen the principal streets in Chillicothe. Two rows of trees had to be removed on the west and south sides of the courthouse to make room for street widening. The Leeper Hotel, seen here at center, was built in 1885 by Andrew Leeper and Sidney McWilliams. It opened with 32 rooms. The first manager was Thomas F. Spencer. The Peoples Savings Bank had a long-term lease on the southeast corner of the building since it had helped to finance the project and had been in that location prior to the hotel. In 1910, the hotel was sold to Bert Clark and Harry Carder. They remodeled the building several times, including the addition of a fourth floor in 1916. (Courtesy of GRHSM.)

In 1897, businesses filled the west side of Washington Street across from the courthouse. From left to right are Swetland Drug, Gitsky's mens clothing, unidentified, Joe Batta Hardware, Palace of Fashion (with Penmanship School above), Market (telephone exchange above), Farmers Store, Lyell and Christian Books (dentist W.G. Goodrich above), and Hartman's Ready-to-Wear (A.W. Wikoff, attorney above). (Courtesy of Vicky England Elliott.)

In the years around 1900, the 700 block of Webster Street on the north side of the courthouse included Sipple Clothing, John F. Hicks Clothing, Owl Drugs, and F.A. Davis' Town Market. Other businesses located there were First National Bank, two tailors, and Crellin Jewelry. Doctors, attorneys, and photographers rented the second-floor rooms. (Courtesy of Vicky England Elliott.)

W.E. and E.M Crellin established Crellin Jewelry at 707 Webster Street on the north side of the square in about 1880 and alternated running it until the 1924 closeout sale. Monte England worked there for more than 12 years as a jeweler, manager, and watch repairman. (Courtesy of Vicky England Elliott.)

HOME OF CHILLICOTHE CONSTITUTION-TRIBUNE UNTIL 1958.

The office of the *Chillicothe Constitution* was at 516 Washington Street from 1902 to 1905, but had moved to 504 Washington Street by 1906, where it remained until 1958. Several generations of the Watkins family ran the Chillicothe Publishing Company, which printed the *Constitution* and, starting in 1928, the *Constitution-Tribune*. They sold their interests in the newspaper in 1972. (Courtesy of GRHSM.)

Brothers Frank and William Scruby bought an agricultural implement business from Peter Young. After a bad fire at their establishment on Washington Street in 1891, they used Young's location on Clay Street next to the Luella Theatre until they were able to rebuild. Their usual location was 506 Washington Street, built in 1893. This image dates to about 1905. (Courtesy of GRHSM.)

The Palace of Fashion was an exclusive millinery shop on the west side of the square in the 1890s selling stylish women's hats. Owner Herman Berg, a Wallbrunn grandson, also ran the Silver Moon Restaurant before joining the Wallbrunn and Berg clothing store. Berg convinced the city to install the first streetlights on Locust Street in 1912. (Courtesy of GRHSM.)

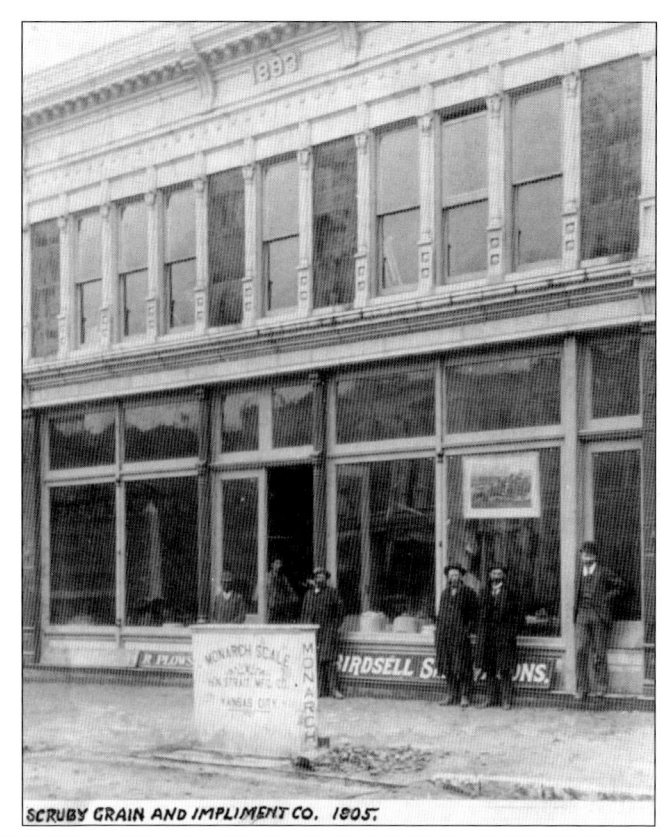

SCRUBY GRAIN AND IMPLIMENT CO. 1905.

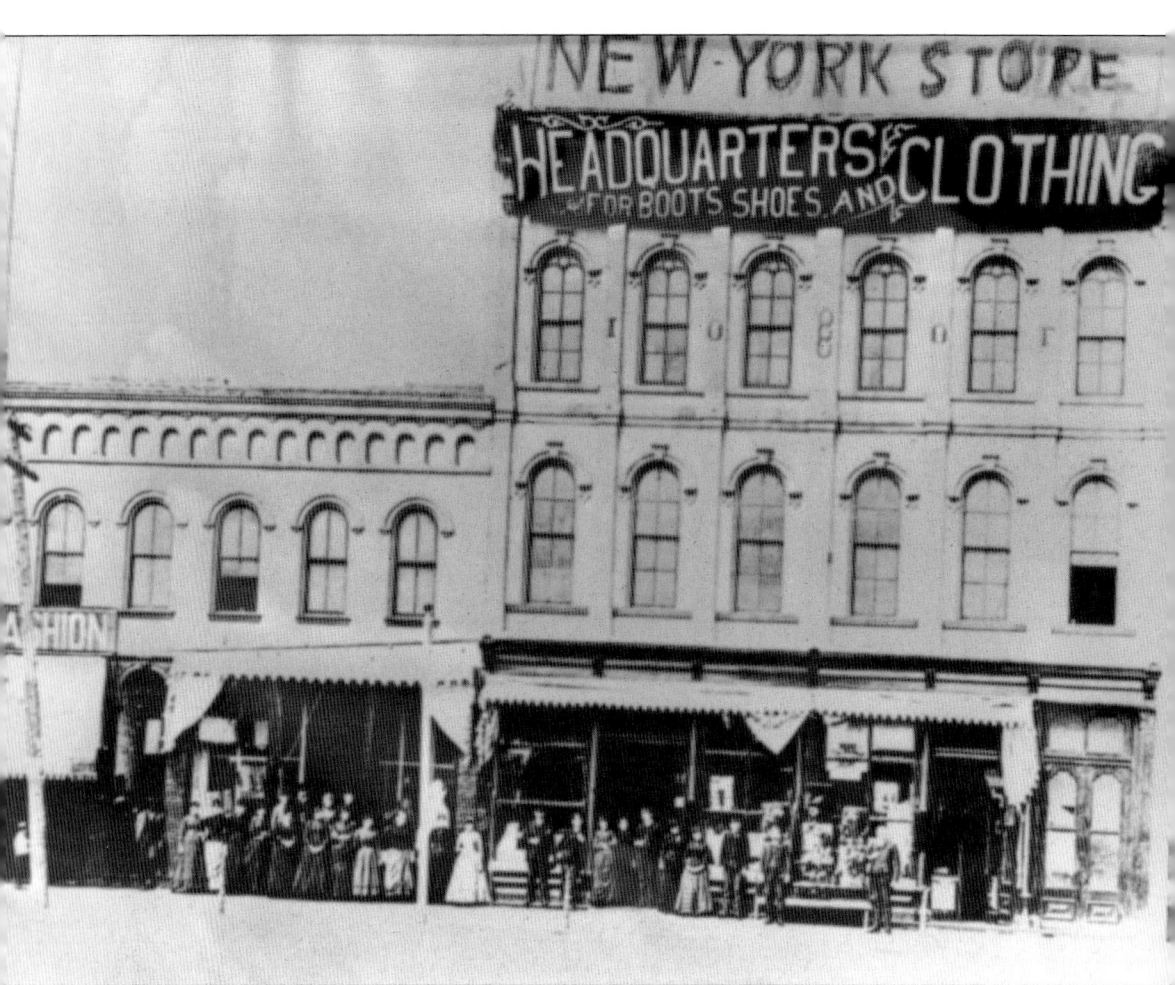

Originally on Locust Street, the New York Store expanded to 614 Washington Street in 1871, where it remained until 1887. The store included clothing, dressmaking, boots, and shoes. Archibald McVey was the driving force behind this business and is seen here at far right. The Odd Fellows met upstairs until their own hall was built in 1891. (Courtesy of GRHSM.)

Citizens National Bank, pictured at the corner of Locust and Jackson Streets in 1918, advertised its vault as being among the strongest in the state at that time. Chartered in 1889, the bank served Livingston County until a 2023 merger. It was the only Chillicothe bank to survive the Great Depression. (Courtesy of LCL.)

Officers of Citizens National Bank standing inside the first-floor counter in 1890 are, from left to right, cashier Dr. W.W. Edgerton, president Thomas McNally, and assistant cashier Frank E. Riley. Joining them in front is McNally's son Raymond, who became a cashier at the bank in 1901. The upper floors of the bank were rented out. (Courtesy of GRHSM.)

The Bank of Chillicothe Savings Association was established in 1866 at the corner of Washington and Jackson Streets. Pictured from left to right are John Middleton, James Mansur, Preston Minor, Charles Mansur, William Mansur, John Brodbeck, and dog Mac. Middleton was from Aberdeen, Scotland, and became a cashier in 1874. Mac was a very friendly and popular Saint Bernard. (Courtesy of GRHSM.)

This was presumably the new location of the First National Bank at 701 Locust Street. The bank purchased the building in 1906 and extensively remodeled it. The grand opening was held on February 20, 1907. T.C. Beasley was president, with E. Kirtley and F.B. Wheeler serving on the board of directors. J.D. Brookshier was the cashier. (Courtesy of GRHSM.)

Saloons were voted out on February 25, 1908. Prior to the election, there were parades, prayer vigils, and speeches, and church bells rang every morning at 10:00 a.m. On election day, hundreds of women and children assembled, wearing badges that read "Vote for Me." They paraded on horseback along with the Markee family band, temperance floats, a water wagon filled with boys, and the Chula band. (Courtesy of LCL.)

Parking along Jackson and Washington Streets near the county courthouse was always congested in 1923. In December 1923, the city council of Chillicothe issued new regulations allowing additional parking down the center of Jackson Street from Cherry to Elm Streets and in the center of Washington Street on the square. (Courtesy of GRHSM.)

N. Harry ran a hotel at the northeast corner of Jackson and Locust Streets in the 1860s. In 1871, this was known as the Browning House, run by a Mr. Swetland. Ziefle and Estep had a general merchandise store on the first floor. The upper floors were hotel rooms. Composer Nelson Kneass died here in 1868. The hotel burned in 1889. (Courtesy of GRHSM.)

The Henrietta Hotel was built on the site of the old Browning House. Clark's Pharmacy occupied the first floor, with hotel rooms on the second and third floors. O.P. Clark bought the property in 1911. This hotel burned in late 1923; Henry Ludwig was trapped on the third floor and died. (Courtesy of GRHSM.)

In 1902, Oliver Perry Clark, a pharmacist, bought a building at Locust and Jackson Streets. Clark's Pharmacy, seen here in 1906, became a Rexall franchise known for its soda bar. In 1911, Clark bought the building, which burned and was rebuilt. After O.P. Clark died in 1950, his son Joseph ran the business, selling it in 1961. (Courtesy of GRHSM.)

Brooks Wigely, a Chillicothe native, was considered one of the best-dressed men in town. His shoe store on Locust Street remained in business from 1913 to 1970. After his sudden death in 1945, nephews Mac and Bill Hunt ran the store. Brooks was a charter member of the Chillicothe Rotary and Country Clubs. (Courtesy of GRHSM.)

The Livingston County Courthouse is barely visible through a thicket of trees in 1951. A sign at the corner reads, "Killers at the Wheel." Union bus station was on the south side of the square, with Bill's Luncheonette next door. Clark's Pharmacy with the Jolly Chef Café and Anderson's Ladies' Ready-to-Wear clothing store sat on the east side of the square. (Courtesy of LCL.)

Jim Lambert opened Mart Cut-Rate Drugs on the north side of the square in 1942. In 1955, he moved it to the west side of the square as pictured here. In 1962, Mart Drug opened in the Leeper building, adding a yarn department, gift shop, and a grill in the basement. Ralph and Joan Willis were the last owners. (Courtesy of GRHSM.)

Seven

OFF THE SQUARE

At the formation of Livingston County in 1837, a county seat was established and laid out. The name chosen was Chilicothe, but due to a clerk's spelling error, it was recorded as Chillicothe. It was named after Chillicothe, Ohio, which is in fact spelled with two Ls. It is a Shawnee word for "big town where we live." John Graves was assigned the task of laying out and selling lots by early September 1837. For some reason, Graves immediately resigned from the commission and Nathan Gregory was therefore tasked. Gregory was a surveyor and able to do the work of creating blocks and lots himself. It was not until 1839 that Chillicothe officially became the county seat.

Chillicothe was first incorporated in 1851 to separate it from the township and then again in 1855 to become a town. It was not until 1869 that a city charter was created, providing for a municipal government with a mayor, city council, and city hall.

Businesses selling groceries, dry goods, hardware, agricultural implements, clothing, and shoes opened along with hotels, restaurants, saloons, and liveries. The first newspaper, the *Grand River Chronicle*, started in 1843.

Father Hugo informed his superiors in 1888 of Chillicothe's need for a hospital. Immediately, the Sisters of St. Mary arrived and opened a much-needed hospital on Eleventh Street, funded by local donations. In July 1916, the Sisters of St. Mary left Chillicothe, and Doctors Grace and Simpson incorporated the hospital as the Chillicothe Hospital. When a new building was needed in 1937, Dr. A.J. Simpson's widow and Dr. H.M. Grace donated the old building, equipment, and property to the city. A new three-story brick Chillicothe Hospital was built on the same property, at 103 Eleventh Street. This photograph shows both buildings sharing the property during the 1937 construction before the old St. Mary's was razed. In 1972, Hedrick Medical Center was built onsite by the city with funding from the Ira and Minnie Hedrick Foundation. The 1937 hospital building became physicians' offices. (Courtesy of Vicky England Elliott.)

A fire department was formed in Chillicothe in about 1886. Thomas McNally built a station in the 1890s at 447 Locust Street, seen here as the single-story building with a canopy next to the feed store. Horses Joe and Dan held the world's record for the fastest fire run in 1898. Between 1896 and 1901, the station building burned and was relocated just south of city hall. (Courtesy of GRHSM.)

Chillicothe fire trucks Nos. 1 and 3 are shown during the county centennial in 1937, in front of the fire department's city hall location. Fire chief Gene Chamberlain is at far left; others include Wilbur Young, Jess Breeze, Walter Forbis, Frank Conway, Roy Lawbon, and volunteer firefighters Bill Gorman, George Hargrave, Eddie O'Brien, O.P. Austin, and Earl Bowen. (Courtesy of LCL.)

The federal building was erected in 1915–1916 and used as a post office, opening in early 1917. The courtroom on the second floor was reserved for use by the Western Division of the Missouri Federal Court. A US Navy recruiting station and the American Red Cross Home Service quickly took over the second floor in 1917. (Courtesy of GRHSM.)

The first city hall was erected in 1869 but burned in 1876. The second stood from 1877 until 1925, when fire again claimed the building. St. Louis architectural firm Bonsack and Pearce designed the third city hall pictured here. It was dedicated on May 6, 1927. Like its predecessors, this building included a large auditorium on the second floor for community gatherings. (Courtesy of GRHSM.)

Livingston County's oldest existing business was founded as City Mills in 1867 by the Milbank family at the corner of Bryan and Washington Streets. The mill ground local wheat into Silver Moon brand flour and made animal feed. While the original mill, built of native walnut logs, burned in 1964, a second location was built on Brunswick Street that continues today. (Courtesy of LCL.)

In 1907, Marion R. Jenkins moved his family and business, the Jenkins Hay Rake and Stacker Factory, from Browning to Chillicothe. Local citizens contributed $16,000 toward the erection of buildings near the Wabash Depot to lure the factory. There were three styles of hay stackers and eight styles of sweep rakes produced here. (Courtesy GRHSM.)

The Jackson Handle and Wooden Ware Company factory is shown here at the southern end of Cherry Street. Thomas Jackson started the ax handle plant around 1890 with business associates Charles and William Ford. The factory employed about 25 men. The building was up for sale in 1913 and later became the Chillicothe Furniture Company. (Courtesy of LCL.)

The Producers Creamery factory was created in 1928 as a dairy cooperative with farmers through "cow contracts." This building was designed by local architect R. Warren Roberts. D.C. Gwinn served as the first president of the board of directors. The butter churned here was first labeled Producers Creamery but was soon changed to Meadow Maid after a naming contest. (Courtesy of GRHSM.)

The lumber yard on Ann Street between Locust and Washington Streets, founded in 1879 as G.C. Hixon Lumber Company, was in continuous operation for well over 100 years with name changes in 1890 to Hannibal Sawmill and 1902 to North Missouri Lumber Company. John Atwell was a manager from 1881 until 1930. In 1986, the company was sold. (Courtesy of GRHSM.)

Cousins Daniel Saunders and Samuel Turner formed the Saunders-Turner Lumber Company in 1883 on Calhoun Street between Washington and Locust Streets. In 1907, Turner bought the Grace lumber yard on Elm Street between Jackson and Webster Streets and moved their business to that location. Robert Lee Rawlins managed the Saunders-Turner lumber yard from 1909 until 1927. (Courtesy of GRHSM.)

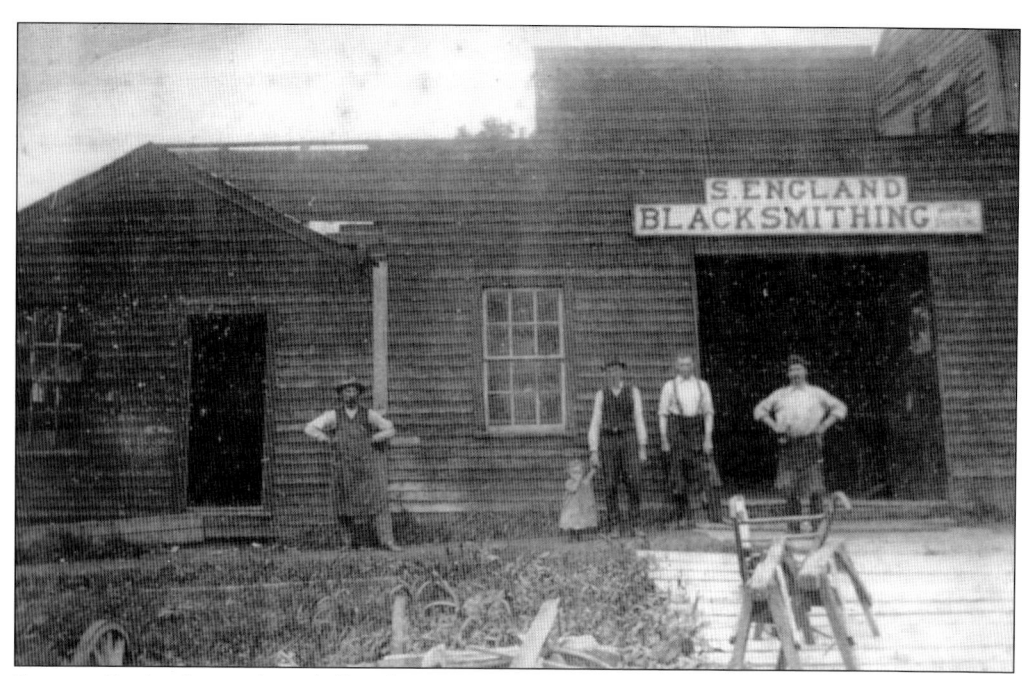

Socrates England moved to Chillicothe in 1865 and became one of the leading wagon makers. His blacksmith shop was at 516 Jackson Street at the southeast corner with Elm Street. His home sat next door to the south on Elm Street. He retired in 1907 and soon after sold the lot to the Elks lodge. (Courtesy of LCL.)

The Elm and Jackson Streets intersection in 1889 included the building signed as "Young, Brown, & Co Farm Machinery," which had become Socrates England's blacksmith shop. James Grace's lumber yard and agricultural implement shop was on Elm across Jackson. Orin Gale had the city livery on Jackson. White picket fences lined the north side of Jackson, while Elm had plank sidewalks. (Courtesy of Vicky England Elliott.)

In early April 1917, the United States entered World War I. When the local Elks club staged a flag raising on May 2, 1917, the newspaper deemed it "the most patriotic demonstration ever witnessed in Chillicothe," complete with parade, prayers, and oration. Great crowds of Livingston County residents gathered in support. (Courtesy of GRHSM.)

Abraham Lowenstein and Albert Eylenberg were wholesalers in produce as well as eggs, poultry, wool, and hides in the 1890s. Their building, seen here in about 1895, was at the northeast corner of Locust and Calhoun Streets. Both men were born in Germany and came to Chillicothe in 1877. Eylenberg died in 1894 at the age of 45. (Courtesy of GRHSM.)

Joseph Pierson, born in France in 1820, brought his family to Chillicothe in 1871 and founded a brewery east of town. Joseph owned a large amount of property and several businesses. He was called a generous employer, participating in anything that would help Chillicothe prosper. In 1877, he turned Pierson's brewery, shown here, over to his son Frank. The brewery closed in 1888. Frank then sold tons of "pure Grand River ice," was a representative of Lemp Brewing Company of St. Louis, and ran a bottling company advertising soda pop "in all flavors." He was elected as Chillicothe Third Ward councilman in 1906 and city treasurer in 1908. In 1909, he was one of the proprietors of Chillicothe Brick and Tile Company with Frank Way and Adam Saale Jr. Frank Pierson followed in his father's footsteps as an enterprising, progressive citizen. (Courtesy of Eva Danner Horton.)

This 1916 photograph shows the Lou Houk saloon with pool and billiards at 601 Jackson Street at the corner of Elm Street. Houk was also an agent for Dick Brothers Brewing Company. "Peg" Kohlman had a chili and tamale restaurant next door and also sold hot wienerwurst. By 1918, this had become the Helf saloon. (Courtesy of GRHSM.)

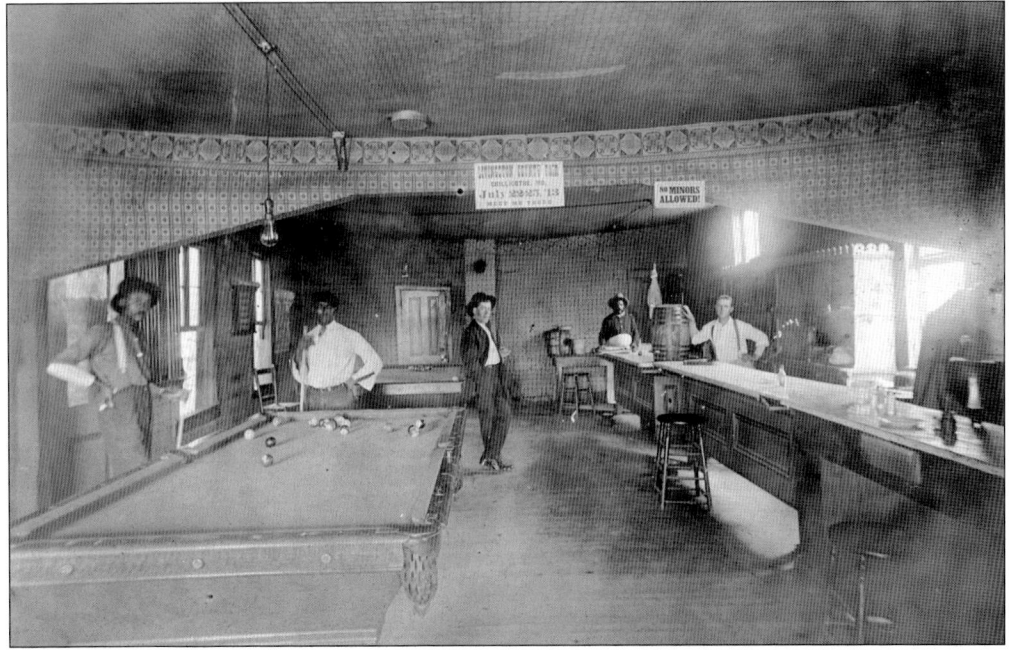

Edmund Ott ran what was known as "Doc Ott's Soup House" at various locations, including 714 Clay Street. His sons Clyde and Charles also worked in the business. Clyde got in trouble on at least one occasion for selling liquor illegally on a Sunday in 1914. He is seen here around 1913 on the right with his customers. (Courtesy of LCL.)

The J.S. McNally Transfer Company was one of the earliest transfer companies in Chillicothe. The business was located in the 700 block of Locust Street on the west side. One carriage has "Leeper House" written across the top. The business also handled feed and coal. This image dates to the late 1890s. (Courtesy of GRHSM.)

This livery and carriage house at the northeast corner of Cherry and Jackson Streets was built in 1875 by Gordon Brown. He sold the business to Zebulon Myers. By 1905, it was run by L.E. Carlton, who had the first nickelodeon in Chillicothe across the street. Around 1908, the livery business was run by E.W. Clark and known as "Clark's Hack." (Courtesy of GRHSM.)

The Chillicothe Street Railway Company ran trolleys from the Wabash and Milwaukee Depots to downtown, Chillicothe Normal School/Business College, Simpson Park, and Renraw Park. Horses pulled the trolley along the tracks. This trolley shows advertising for the *Mail and Star* newspaper, which operated from 1893 to 1900. Other advertisers included Mohrs & Son Furniture Dealers and Undertakers and Chillicothe Steam Laundry. (Courtesy of LCL.)

Monroe Street, the gateway to Chillicothe Business College, was paved in 1916. Brick paving was done from Polk to Bryan Street in August by the crew of contractors John F. Meek and C.A. Stewart. In November, Monroe was paved from Bryan to Irving Avenue, giving the First Ward more paved streets than any other in Chillicothe. (Courtesy of GRHSM.)

In 1877, the *Crisis* was started as a weekly Democrat newspaper by Thomas Lankford and Robert Reynolds. In 1878, Paul J. Dixon, an attorney, bought Reynold's interest and the paper changed to the *Chillicothe Weekly Crisis* with a Greenback viewpoint. Dixon and Lankford also published daily the *Evening Star* (1885–1893) and a nationwide Populist monthly, *Missouri World*. (Courtesy of GRHSM.)

This building at 610 Jackson Street was erected around 1917 by Fred B. Wheeler of Wheeler Plumbing and Heating, with the Wheelers living in the upstairs apartment. In 1933, this became the Green Lantern Café. In 1940, it was the Garden Café. Tory's Auto Parts was located here from about 1947 to 1950. (Courtesy of GRHSM.)

In 1885, C.F. Adams established the Adams & Sons Wholesale Grocery, seen here at center left, which quickly became one of the largest suppliers in northern Missouri. In 1915, Adams erected a mammoth car dealership at 440 Locust Street with showrooms on the first and second floors and an automotive repair shop on the third floor. (Courtesy of the Charles G. Adams family.)

Looking north on Locust Street

Around 1887, Archibald McVey erected a massive New York Store at the corner of Locust and Clay Streets. St. Louis architect Charles Clark returned to design this building using the first metal roof shingles in town. Maupin College and the Masons used the upper floors at various times. The store sold kitchenware, carpeting, furniture, ladies' clothing, and shoes, with a restaurant in the basement. (Courtesy of Vickey England Elliott.)

Frank Brown, far left, was manager of the second-hand shop in 1891. H.O. Meek is at far right and also had businesses here. The building was erected on Locust Street in 1883 by Meek for W.E. Gunby and J.T. Johnson's Tobacco Company. "Factory No. 20" refers to their government license number. This was next to the fire department in the 1890s. (Courtesy of GRHSM.)

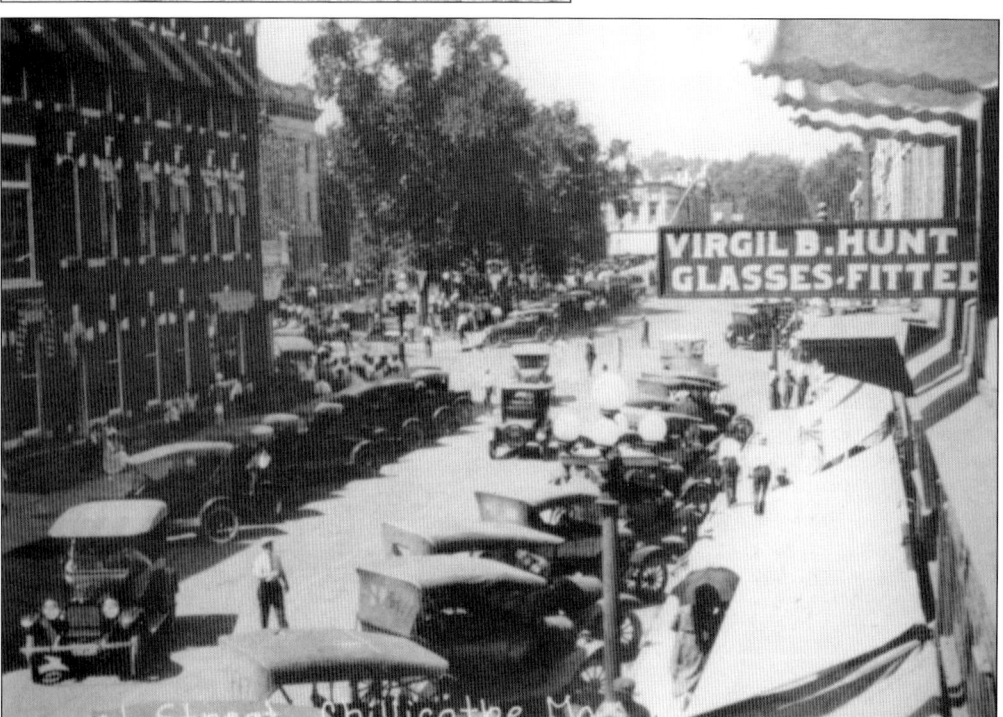

The 500 block of Locust Street, southeast of the square, was a busy place in the 1920s. Various businesses here between 1892 and 1940 included Boehner's Meat Market, Henry Clem Grocery, Molloy Jewelry, Wigely Shoes, McGuire Millinery, Shearer Hardware, Moren Photography, the New York Store, and Ed Moss Dentistry. (Courtesy of GRHSM.)

The Grand River in Livingston County reached a record high on June 7, 1947, outdoing the Great Flood of 1909. All road and railroad travel halted. Spectators flocked to the Red Ball restaurant and service station, pictured above, to view the floodwaters near the junction of Highways 36 and 65 at Chillicothe. To the south on Highway 65, the Bend gas station and tourist cabins had water reaching the windows. Highway 36 was underwater all the way west to Utica and was flooded by Medicine Creek to the east. The detour suggested in the sign at right was soon flooded as well. A *Kansas City Star* editorial at the time pointed out that previously proposed flood control reservoir projects had been opposed in Livingston County. (Both, courtesy of LCL.)

Charles H. Mast and A.E. Cox were proprietors of Mast and Cox garage, in the old Wilson livery barn at Calhoun and Locust Streets. Ed Gallatin stands on the left, with Cox at right. Cox and Gallatin's wives were cousins. On October 1, 1920, the old barn burned. Mast and Cox lost their tools and a rebuilt Ford car. (Courtesy of GRHSM.)

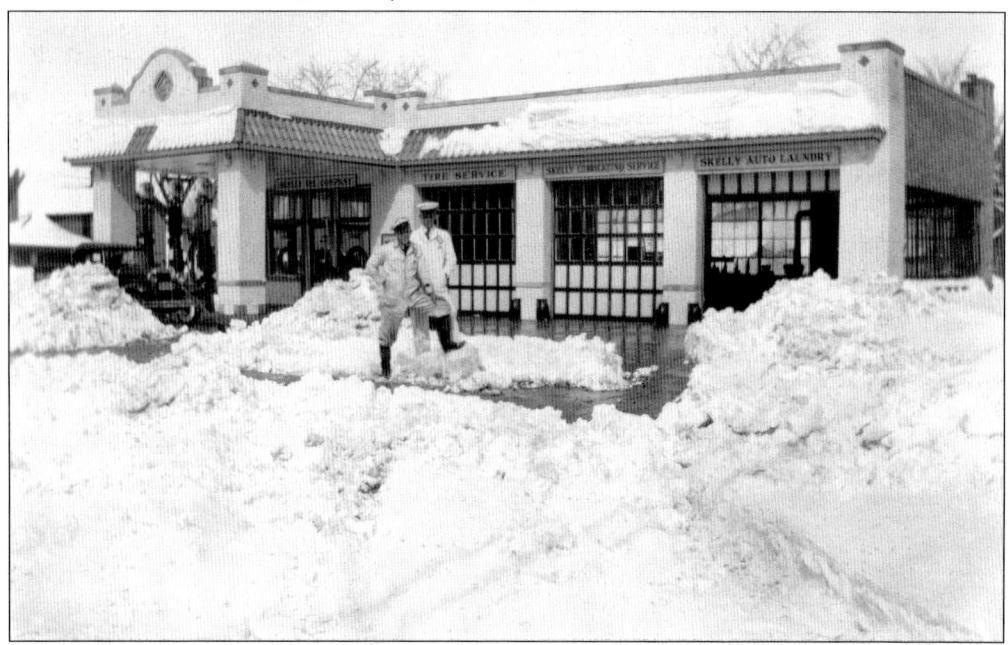

In 1930, the Skelly Oil Company bought the old Gord Brown Livery Stable building at 829 Jackson Street and hired contractor John Meek to tear it down. The new Skelly Oil service station opened on February 7, 1931, managed by "Hoopy" Haston. In 1959, it became Courtney-Wood Oil, providing full service for the next 20 years. (Courtesy of GRHSM.)

Eight

MILITARY

The men and women of Livingston County have long served in our nation's military to protect and defend our democratic ways of life. While many served in the War of 1812, the Civil War left lasting imprints on our county. Most citizens were pro-Confederate at the start of that war, but by the end, most were for President Lincoln. Troops were formed for the Spanish-American War in 1898. World War I saw many men answer the call of duty, both white and black. The first Livingston County resident to fall was George Ostrander; at least 31 never came back. World War II saw over 1,100 young men from the county serve in the war, and over 2,200 civil defense volunteers helped out at home.

Women have long helped in capacities other than the front lines. In World War I, they formed chapters of the American Red Cross to help with the effort. In Chillicothe, they took over most of the space in the newly constructed federal building as well as the parish house for Grace Episcopal Church to make bandages and hospital gowns. Three women served overseas as nurses in that war: Ruth Page Vornbrock, Emma Evans, and Roberta Beat. Citizens again mobilized during World War II. Over $5 million in war bonds were sold. Rationing of all sorts of items became the norm; even steel for bread-cutting machines was banned for a short time to save on materials. At least 58 men from Livingston County lost their lives serving their country.

Vincent Carpus Bruce helped form the 18th Missouri Company C and served as a lieutenant in the Civil War. In the 1890s, he became a fruit farmer on the western edge of Chillicothe on Third Street. He later moved to a house on East Clay Street. (Courtesy of the Mouton family.)

Local Confederate veterans met yearly to commemorate winning the Battle of Lexington, Missouri (September 18–20, 1861). By 1928, only G.W. Kent, J.H. Dyer, J.J. Stith, W.H. Mansur, and J.A. Shirley attended. Mansur originated the plan to push hemp bales ahead of the troops as shields. Shirley was the last Confederate soldier in the county when he died in 1935. (Courtesy of GRHSM.)

This original roll of the Missouri 23rd Regiment Infantry, Company G, has been handed down in the Brookshier family. Their great-great-grandfathers Pvt. Newton J. Hicks and Cpl. James M. Wilson were part of the unit. Company G was mustered into Federal service at Chillicothe in November 1861. The company saw action at the Battle of Shiloh, Tennessee, on April 6, 1862. Their commanding general applauded the regiment for a job well done, despite 5 men killed, 25 wounded, and 25 taken prisoner. The prisoners were returned to duty on January 2, 1863. The Missouri 23rd Regiment went on to follow General Sherman to the sea and was present at the Siege of Atlanta, the Siege of Savannah, and the surrender of Johnson's army on April 26, 1865. The unit was mustered out on July 18, 1865, at Louisville. (Courtesy of Dean Brookshier and Donna Brookshier Good.)

Organized May 1, 1891, with officers commissioned on June 6, the most courageous Livingston County young men formed The Leach Rifles, Company H, Missouri State Militia, named in honor of organizer Col. W.B. Leach, cashier of the People's Bank. Pictured here, the company paraded on unpaved Washington Street, north of Webster Street near city hall while preparing to serve at the 1893 Chicago World's Fair. City hall is behind them on the left. Workers of Goodway Publishing and Smith and Dienst Law offices appear in the upstairs windows of the building. In 1897, this unit became Company H, Missouri Volunteer Infantry, a forerunner of the Missouri National Guard. Officers included Capt. C.A. Grace, 1st Lt. O.W. Edmonds, 2nd Lt. J.M. Grace, and Sgt. A.D. England. The company drilled weekly on Thursday evenings at its armory over Conger & Botts store. (Courtesy of LCL.)

"Boys in Blue! Attention!" read the advertisement for the "Soldiers Re-Union" sponsored by the six Livingston County chapters of the Grand Army of the Republic on October 1–3, 1884. An "immense crowd" turned out for drills, parades, cannons, and fireworks, with the brass band pictured here performing. General Sherman was even invited. The Grand Army of the Republic was a fraternal organization for Union soldiers from 1866 until the final member died in 1956. (Courtesy of GRHSM.)

These men in street clothes wielding rifles are undergoing "emergency military training" before leaving for duty in the Spanish-American War on April 25, 1898. Chillicothe's Company H, 4th Missouri Infantry, served less than one month, mustering out on May 16. Twelve years later, the soldiers received their back pay on August 12, 1910. Privates got $24.48, sergeants $32, and Capt. Judge F.S. Miller received $94.50. (Courtesy of GRHSM.)

After local National Guard Company I was mobilized for World War I in August 1917, the 52nd Separate Company of Missouri Home Guards replaced them on the home front. Seventy-five working men mustered in, drilled weekly, and served where ordered. Capt. C.T. Botsford ran the unit on meager state supplies and local donations. The company was mustered out and disbanded on June 9, 1919. (Courtesy of GRHSM.)

American Red Cross chapters sprouted up all over the county during World War I thanks to the efforts of Inez Duffield and Josephine Norville. These groups became masters at rolling bandages and sewing hospital garments as well as holding fundraising events including dances, ice cream socials, and picnics. Many men were also involved, helping with supplies and equipment and raising money for the war fund. (Courtesy of LCL.)

Auxiliary branches of the American Red Cross blossomed throughout Livingston County. Originally part of Rich Hill, these ladies split to form their own group, South Precinct, on March 2, 1918, on property donated by J.F. Winans. They raised a total of $833 and turned out 1,159 items of clothing, bandages, and other needed supplies. Leading the group were Elizabeth Winans and Frances Stewart. (Courtesy of LCL.)

Brig. Gen. Lewis Means gave the address on November 7, 1940, at the dedication ceremony for Chillicothe's long-awaited new armory, which he called a link in the national defense that would keep America out of war. R. Warren Roberts was the architect. All work was done by WPA manpower, using no machinery and providing income to many. The project was funded by federal, state, and local efforts. (Courtesy of LCL.)

In 1942, the Chillicothe Business College contracted with the US Army to provide seven-month Air Force Clerical School training. The entire five-floor Strand Hotel was converted to barracks housing airmen. Local men were hired for a 24-hour security force to guard both the barracks and the classrooms. Among the guards pictured here are three men experienced in law enforcement: supervisor Roy Uhrmacher, Oliver Hicks, and Oran Anderson. (Courtesy of GRHSM.)

At the home of Russell Brookshier, US Navy, World War II, the family supported the war effort by reusing cloth feed sacks, as did most patriotic rural Americans. The window curtain behind him is made from a cloth sugar sack. The War Production Board regulated the sizes and colors of these sacks, encouraging people to trade and share them for sewing clothes. (Courtesy of Dean Brookshier and Donna Brookshier Good.)

Marion Harter was from St. Joseph, Missouri, and served in the US Navy from 1944 to 1945 on the USS *Duluth*. He married Sue Rose Mounce, daughter of Nadine Dome and Earl Mounce of Utica, in 1950. This photograph shows him on the Dome/Mounce farm in Utica with a favorite horse. The last generation of Harters lives on the farm now. (Courtesy of Rosina and George Harter.)

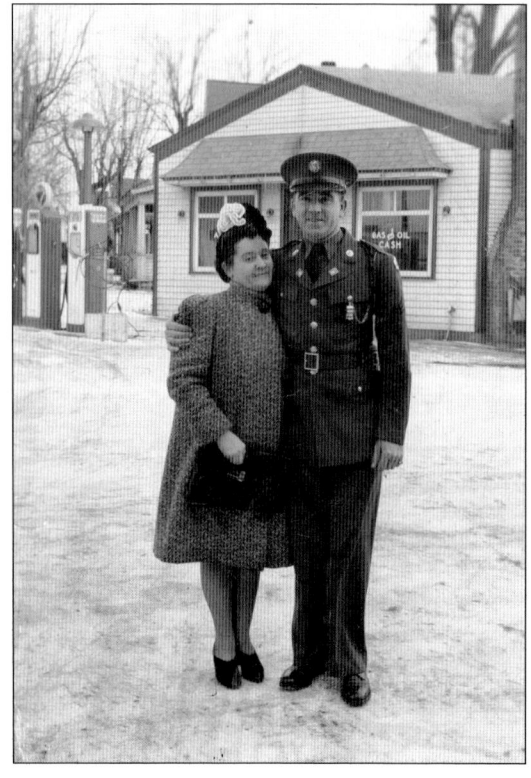

Sgt. Don L. Cruse, the second Livingston County man to enlist voluntarily rather than wait to be drafted after Congress passed the Selective Service Training Act of 1940, entered the 2nd Parachute Training Regiment and spent the war at Fort Benning, Georgia, readying paratroopers for European and Pacific invasions. His early enlistment ended in 1944. He was welcomed home to Ludlow by sister Fanny Wells. (Courtesy of the Anderson family.)

In World War I, Mooresville's R. Warren Roberts served in the Army. During World War II, he taught engineering for the Navy. Roberts was a prolific architect, designing the Livingston County courthouse, Adams Automobile Supply Company, Chillicothe High School, First Christian Church, several buildings at the Industrial Home for Girls, and the gym at the Chillicothe Business College. He also designed Braymer, Utica, and Avalon schools. (Courtesy of the Roberts family.)

The St. Louis Ladies Auxiliary Drill Team of the United Spanish War Veterans, accompanied by a Kansas City drum corps, entertained with formations on the courthouse square during the 37th State Encampment on June 15-18, 1941. Barnes Chevrolet furnished the truck for the parade. Chillicothe Camp No. 62 adjutant H.D. Snyder and the local Home Guard members assisted with the arrangements for over 600 attendees. (Courtesy of GRHSM.)

Nine

PEOPLE

The first inhabitants in Livingston County were Native American Indians, with tribes of Missouri, Iowa, Sacs, Fox, Kickapoo, and Pottawatomie. They had several settlements in the area and hunted throughout the region. French traders would have been the first white men to enter the territory, possibly as early as the 1700s and certainly by the early 1800s, with a French fort in 1828 at the mouth of Locust Creek in the southeastern part of Livingston County.

The earliest pioneer settlers came from neighboring states and counties and settled in the wilderness. They were brave and hardy folk who had a vision for a new life. Communities formed, towns grew, and civil governments matured. Some people farmed the land while others started bakeries and restaurants or opened shops for blacksmiths, agricultural implements, and cigars. Clubs and organizations formed, including the Livingston County Poultry Association and numerous highway associations. A county-wide library was started by a group of women's clubs as a memorial to the soldiers of World War I. Automobiles appeared on the scene. Through the tough times, there was still music and laughter, family, friends, and neighbors.

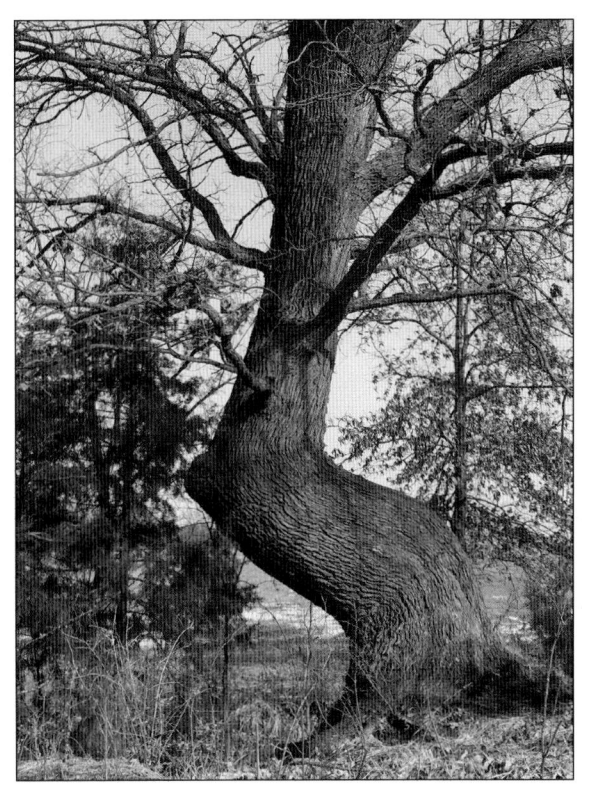

This tree is believed to be a Native American trail marker tree and is close to 300 years old. Certain trees were bent as saplings and then used to point the way to water sources, trails, and other significant locations. This oak in the Muddy Lane area is on the Trail Tree Project Registry and is one of the oldest in the country. (Courtesy of Peery/Doughty.)

Charles F. Adams was president of three highway associations at the advent of the automobile age and helped dub Chillicothe "the Highway City." He was instrumental in the formation of the Pikes Peak Ocean-to-Ocean Highway, which connected New York to Los Angeles via Chillicothe; Route 36 roughly follows the route today. Adams served as the Ocean-to-Ocean Highway Association's first president from 1911 to 1920. (Courtesy of the Charles G. Adams family.)

Pictured from left to right are Marie, Stella, and Edith Ancell, three of eight children born to Mary (Shoush) and James Madison Ancell, a carpenter. The family moved to Chillicothe from Fayette County, Missouri, in 1887, and lived at 113 Herriford Street. Note the same hairstyle for all the young ladies. (Courtesy of LCL.)

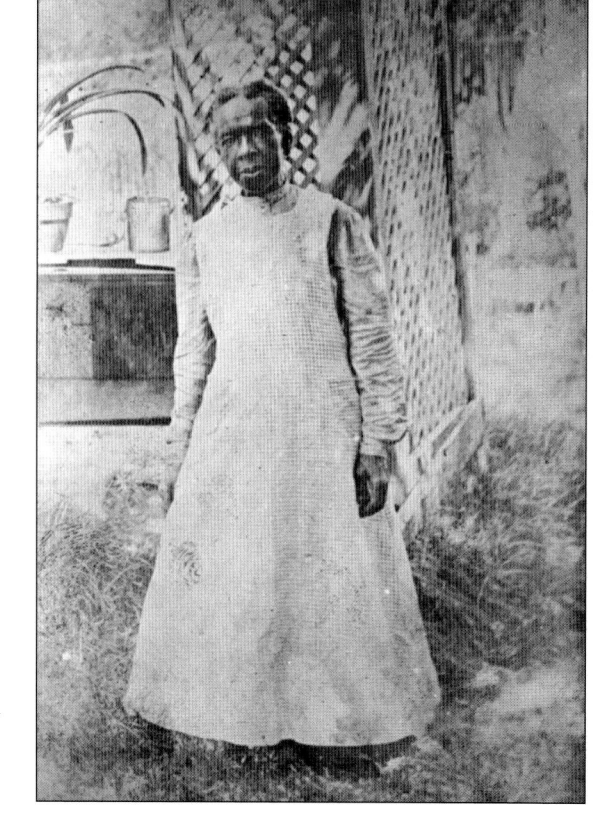

This photograph is from the Ancell/ Ott collection. One other copy is known from the Inmans, another Chillicothe household. Perhaps this is Malinda Lewis, a midwife known as "Aunt" to many. Or maybe this is Laura Wright, a janitor at the courthouse who knew everything that happened in Chillicothe. (Courtesy of LCL.)

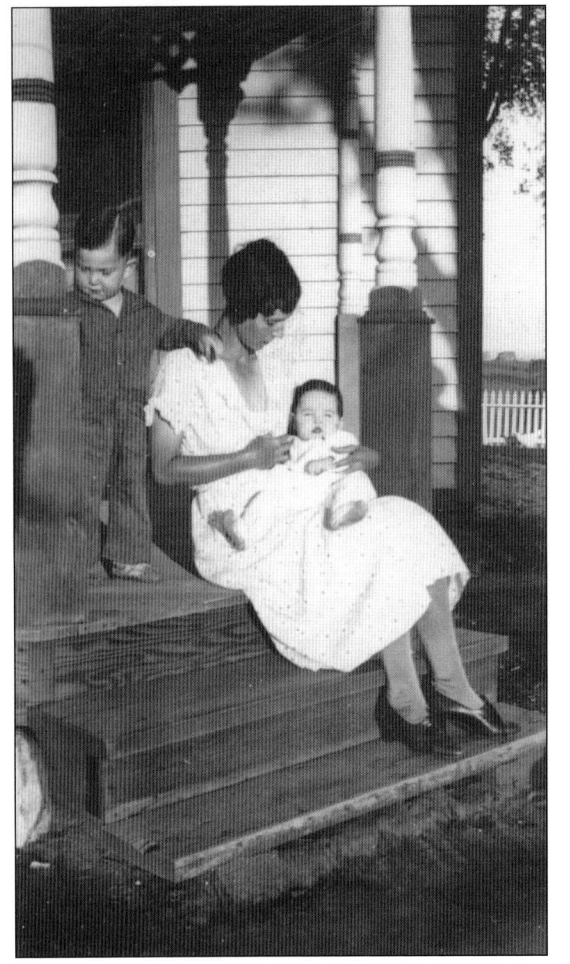

Like many other young Livingston County farmers in 1919, Elmer Cruse had worked and saved to buy his first team of horses and was delighted with his new transportation. Just a few years later, he drove that team into town and returned driving a new car to surprise his wife. In the 1920s, times were changing rapidly in the county. Automobiles were becoming popular. (Courtesy of the Anderson family.)

Young mother Myrtle Cruse took a rare moment in 1934 to sit and play with her children Donnie and baby Grace. Mothers labored long hours cooking over wood stoves, pumping and carrying water to the house, putting up their own foods, washing diapers by hand, gathering eggs, and working in the garden. County farms had no electricity yet to make life easier. (Courtesy of the Anderson family.)

Marion Franklin "Frank" Bench was born in Utica, went to college in Iowa, and came to Chillicothe in 1916. His Modern Steam Bakery opened at 433 Martin Street next to his home on Clay Street. In 1921, he built a new bakery at the corner of First and Elm Streets, calling it the Chillicothe Baking Company. He added a line of mayonnaise and thousand island salad dressings that were so popular that their production was moved to the old bakery on Martin Street in 1923 and run by his wife, Hattie. Frank was involved with Otto Rohwedder in designing a bread box and a bread rack display and helping Rohwedder perfect his bread-slicing machine. On July 7, 1928, Otto's son Richard pushed a loaf of Kleen Maid bread through the slicer. This was the first commercially sliced bread in the world. Production at Frank's bakery increased by 2,000 percent in the first two weeks as bakers from the entire region came to Chillicothe to use the bread slicer. (Courtesy of Debbie Colton.)

Maurice Dorney became the first chief of police in Chillicothe, appointed in 1898 and elected starting in 1900. Dorney was a rare combination of tough, fair, shrewd, and kind, liked and respected by both citizens and criminals. He said his commonsense approach originated from advice given to him early in his career by Capt. Bartholomew "Bat" Masterson. Chillicothe saw no bank robberies while Dorney was chief of police. He arrested criminals of all kinds, ranging from chicken thieves to bank robbers. Probably the most important arrest he made occurred in 1905 when he and two patrolmen arrested four men who had robbed the Iowa State Bank at Udell. The robbers were in a saloon on the south side of the square in Chillicothe when Chief Dorney and his men entered through different doors with drawn revolvers and got the drop on the thieves. (Courtesy of GRHSM.)

Women first voted in the November 2, 1920, election. The first woman in Livingston County to cast her ballot was Utica's Rosina Dome, pictured here. In Chillicothe Wards One through Four, the first women to vote were Caroline Shirley, Mrs. George Babb, Margaret Henton Gray, and Sallie Shives. The newspaper mentioned that "colored women also voted" but no mention of names was made. (Courtesy of Rosina and George Harter.)

In 1920, Socrates England was the second-oldest Odd Fellow in the United States, shown here wearing his collar and white satin apron with hand-painted emblems that he purchased in 1857. He served in all positions during his 65 years in that organization. In 1867, he became a Mason and remained in that society for over 50 years. (Courtesy of the England/Ramsey families.)

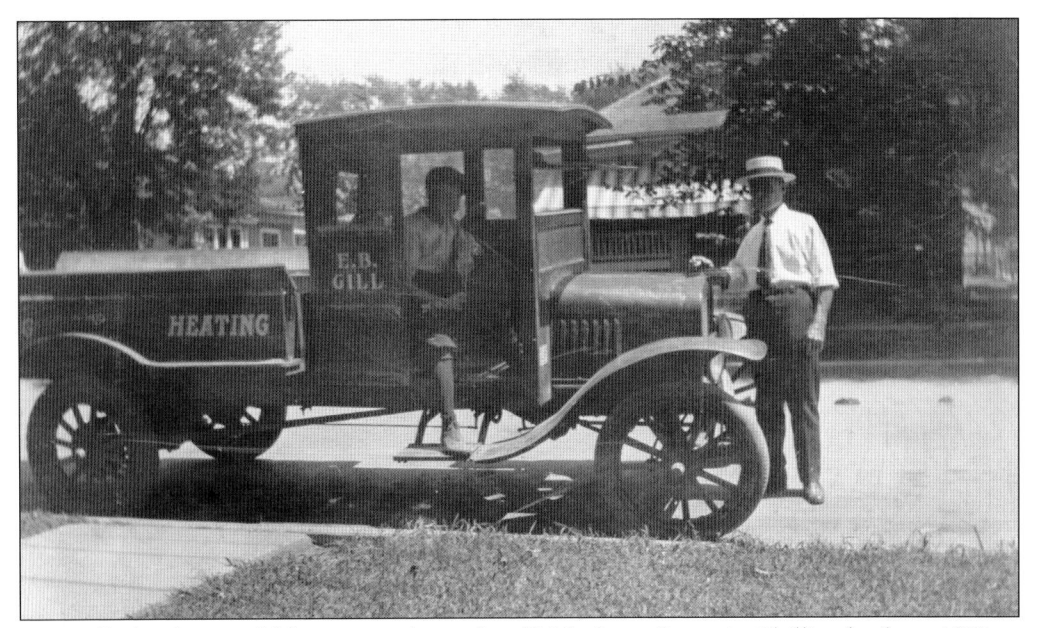

E.B. Gill Plumbing and Heating was located at 820 Jackson Street in Chillicothe from 1892 to 1925. In 1922, Gill won the $14,616 contract to do the plumbing and heating on the new laundry behind Marmaduke Cottage and the new school building at the Industrial Home for Girls. He had done work on architect R. Warren Roberts's new Braymer High School in 1921, among other projects. (Courtesy of Rosina and George Harter.)

In 1910, one of Chillicothe's most popular young men stepped out to direct traffic at Locust and Webster Streets. Later, Elmer Goben was a second lieutenant with Company I, 4th Infantry, Missouri National Guard; a building contractor constructing local homes; a candidate for presiding judge of the Livingston County Court; and treasurer of the Law Enforcement League. Olive Rambo Cook acknowledged Goben for drawings and information in her book *Serilda's Star*. (Courtesy of GRHSM.)

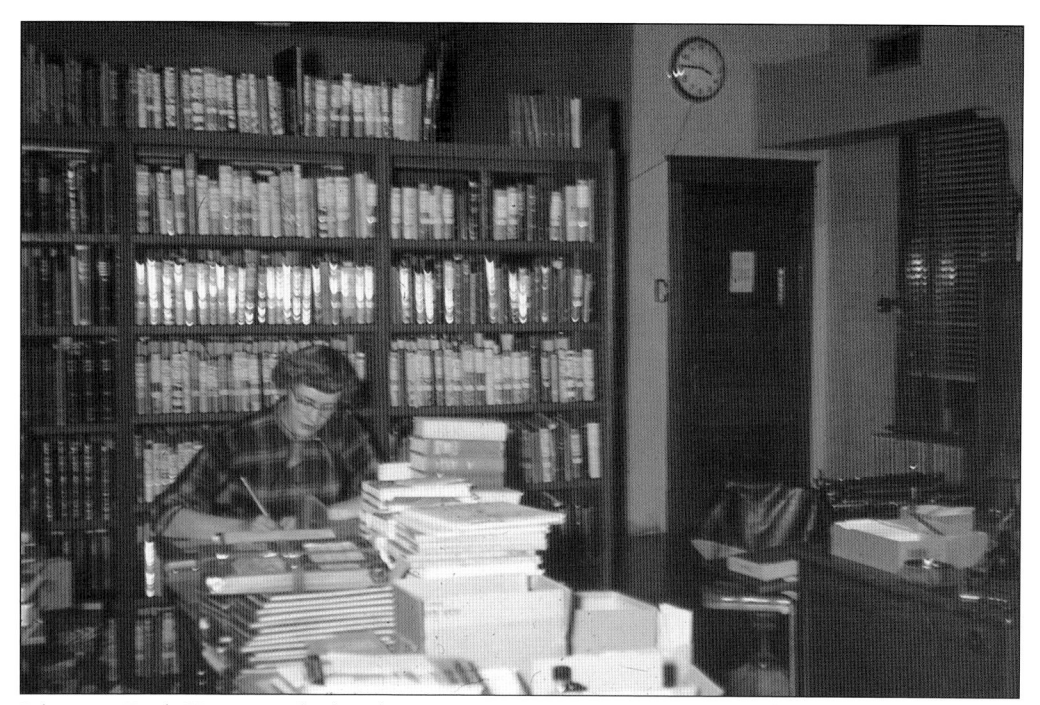

Librarian Ruth Harris worked at the Livingston County Memorial Library. From 1948 to 1965, the library was at the southwest corner of Washington and Jackson Streets. Harris was the acting director in the early 1960s while librarian Elizabeth Coffman went for her library degree. Harris was the assistant librarian for many years and was acting director again between directors Coffman and Lillian DesMarias. (Courtesy of LCL.)

The Home-Made Ice Cream Place at 803 Calhoun Street became a Chillicothe icon of the 1940s and 1950s after John Goodman opened it near Chillicothe Business College, Ben Bolt Theater, and city hall. Subsequent owners, the Hurless King family, pictured here, continued making 22 ice-cream flavors such as banana nut, scotch wave, and licorice (59¢ per half-gallon), scooped from countertop freezers for cones and malts. (Courtesy of Shanda Feeney and Jo Anne Frazier.)

Around 1900, motor cars began appearing in Livingston County. G.A. McBride is driving one of the earliest in this photograph taken on Locust Street beside Citizens National Bank. McBride was in the grocery business at 32 Washington Street for nearly 40 years, was county treasurer for one term, and served as assistant cashier of Farmers and Merchants Bank for nearly three years. (Courtesy of Vicky England Elliott.)

Andrew J. and Minerva Ann (Fryer) McCoskrie, well-known gospel singers in 1894, performed around the county with their seven children. Andrew crossed the plains by wagon to California in 1849, found some gold, and returned home later by ship around South America, up the Mississippi and Missouri Rivers, and continuing home on foot. (Courtesy of Kathy Cox and Rhonda Bondurant.)

Normal
Photo.
Gallery.

Chillicothe Normal & Business College

R. L. Russell,
Artist and Teacher
of Photography . . .

ALLEN MOORE, PRESIDENT CHILLICOTHE, MO.

In 1890, Allen Moore opened a teacher training school in Chillicothe. Previously, he served as president of the Stanberry Normal school. Moore's slogan was "a business education in reach for all." He served as president of the normal school until his death in 1907. He is shown here in about 1895 with his wife, Emma, and children (from left to right) sons Allen Jr. and Ralph "Roy," and daughters Irene and Beth. (Courtesy of GRHSM.)

McKnight Chillicothe, Mo.

Stephen N. Norris Jr., born in 1819 in England, moved to Chillicothe in 1868 and started an agricultural implement business with Wesley Jacobs. In 1877, he was involved with the University of Missouri at Columbia for an assessment of the effectiveness of various plows. His children gave him the gold-tipped cane seen here for his birthday in 1883. (Courtesy of the Mouton family.)

Jesse B. Ott was born in Livingston County in 1876. He and his brother Clyde ran a lunch counter on Clay Street between Elm and Locust Streets. Ott was also a cigar maker with business partner Bill Booth above 606 Washington Street. In the 1920s, he was a state district game warden, responsible for several counties. Here, he poses with his prize-winning rooster. (Courtesy of LCL.)

Around 1903, Lulu May Weston was secretary for the Missouri State Poultry Association and the Livingston County Poultry Association. She moved to St. Louis, where she was the bookkeeper and office manager for a store. In 1907, she married Jesse Ott and came back to Chillicothe. In 1915, she was the only female poultry judge in Missouri and one of only two in the United States. (Courtesy of LCL.)

John Hutchison Peery of Jackson Township rode a horse to Springfield, Missouri, in 1861 to enlist with the Confederacy and saw action in battles at Wilson's Creek; Elkhorn Tavern; Pea Ridge, Arkansas; Corinth, Mississippi; and Vicksburg, accompanying Gen. Sterling Price's troops. His father, William Frances Peery, a colonel under General Slack's command, was murdered by Federal vigilantes near Bedford, Missouri, in 1864. (Courtesy of Peery/Doughty.)

In 1918, Myrtle Shields graduated from the two-year Ludlow High School along with Murriel Johnson, Vivian Busby, Jesse King, Garnet Welker, and Vernon Cosner. At that time, there were eight public high schools in the county towns of Avalon, Chillicothe, Dawn, Ludlow, Mooresville, Utica, and Wheeling, along with St. Joseph's Academy of Chillicothe. Ludlow students would sometimes continue their education with two final years at Dawn. (Courtesy of the Anderson family.)

In the 1930s, most rural communities had no electricity, running water, or sewers. Homes had no plumbing. The life of Livingston County women during the Great Depression required hard work on shoestring budgets. Effie Switzer pumped and carried water from the well in her yard on Main Street in Wheeling as one of her many everyday chores. (Courtesy of Dorothy Switzer Spidle.)

Sampsel resident Jim Wilson was born in Illinois in 1840. His parents were friends of young Abraham Lincoln, who came to visit the newborn and suggested the name "James Madison." While he had no children, Wilson reared 13 orphans and acquired the nickname "Uncle Jim." After serving in the Civil War, he married Mary "Mollie" Lyon. After her death, he married Amanda Jones Gann. (Courtesy of LCL.)

Ten

ENTERTAINMENT AND SPORTS

Early settlers enjoyed simple entertainment with musical instruments, singing, storytelling, socializing, and perhaps reading. By the 1850s, residents were putting on shows in whatever public space was available. Occasionally, a traveling troupe of actors, a ventriloquist, or a magician would come calling. The completion of the Hannibal to St. Joseph Railroad allowed many more people to come into the Livingston County area much more easily. Circuses began to make the routes; imagine traveling with a slew of wild animals by train or wagon. Other forms of entertainment came along, such as horse and wagon racing and horse shows. Local musicians formed a variety of bands. Opera houses offered more quality entertainment including plays, guest speakers, and sporting events like boxing. In 1905, moving pictures reached Chillicothe and took off, with a substantial number of nickelodeons appearing between 1905 to 1910. Once schools were well established, sports teams formed and competed with one another. Adult sports teams followed, such as baseball and bowling leagues. Sometimes, the area received a special visitor or event that sparked the interest of residents. Movie theaters matured and offered daily entertainment.

In 1871, P.T. Barnum's Great Circus "gigantic parade" rolled south on Locust Street. Boals & Stewart Hardware store faced north on Jackson Street. The New York Store, owned by Murray and McVey, is at center. Just south of them was General Dry Goods run by Menefee and Pepper. The towers of Platter Brothers Stables are barely visible. (Courtesy of State Historic Society of Missouri Digital Collection.)

In the 1890s, the Gentry dog and pony traveling circus came to Chillicothe. They paraded around the square, seen here heading south on Locust Street and turning west onto Jackson Street. The old Henrietta Hotel can be seen at far right. They would set up tents in an open area and their dogs and ponies would perform a variety of tricks. (Courtesy of GRHSM.)

In the 1870s, John Smith organized a band in Chillicothe to provide entertainment. A formal concert band was formed in 1891 by Ed Strong with weekly concerts in Elm Park. This Chillicothe Cornet Band was formed in 1890. From left to right are Frank Deiter, Dave Sproul, James Watkins, Dan Saale, George Strong, Lou Troug, Ed Strong, Fred Scholl, Jack Schneider, C.L. Rutherford, Charles Brown, and Jess Saale. (Courtesy of GRHSM.)

The Luella Grand Theatre was built in 1895 by Zebulon B. Myers and named after his wife, Luella Lile. It was inspired by the famous Ford's Theatre in Washington, DC, with balconies, curved loges, plush seating, and parquet flooring. It offered plays, boxing matches, graduations, speakers, and eventually moving pictures. In 1905, Myers embellished the outside, adding a fire escape and portico with a colored-glass border, as seen here. (Courtesy of GRHSM.)

This looks like it could be the Modern Woodmen or Royal Neighbors picnic with pony and wagon races. A line of faint handwriting states that this is the Colt Show put on by I.W. Everson in late September 1909. There is an automobile just to the left of the bleachers. (Courtesy of LCL.)

The 1926 Chillicothe Junior-Senior High School basketball team stands in front of their two-year-old school. From left to right are (first row) Junior Hatcher, Bill Nothnagel, Clarence Potts, Calvin Clements, and Charles Kalley; (second row) coach Taylor Dowell, Bowman, Carl Snavley, Donald Stewart, Freddy Bayles, and Gibson Adkins; (third row) Joe Bumgardner and Reggie Fair. Coach Dowell became a legendary speech teacher and principal, retiring in 1967. (Courtesy of LCL.)

In 1890, the North Missouri Agricultural and Mechanical Society held its first fair on their grounds, which now include Simpson Park and the Chillicothe Country Club, with a half-mile race track at the north end. Over 200 horses participated in races in 1913. The society could never make it a profitable endeavor and sold a portion of this area to the Chillicothe Country Club in 1923. (Courtesy of GRHSM.)

Rubye Hoerath ran away from the farm in Sampsel Township and became an equestrian performer with the Ringling Brothers Circus in the 1920s and 1930s. She married several times, raised two daughters to be trapezists, lived all over the United States, and ended up in Morningside Center, Chillicothe, where few people knew of her colorful life. Local Gann and Dryden relatives remember her fondly. (Courtesy of Dean Brookshier and Donna Brookshier Good.)

The Lucky Strike Bowling Alley in the Lambert Manufacturing building on Jackson at Vine Street in Chillicothe hosted men's bowling leagues in the 1940s. The Chuck's Taxi team in 1946 included, from left to right, Raymond and Clarence "Bro" Gladieux, Carl D. Weeks, "Red" Bowman, and Ray Jeffries. The Gladieux brothers and Bowman were top bowlers. The alley moved in 1947 to 711 Curtis Street. (Courtesy of GRHSM.)

The Northwest Missouri Shamrocks won the annual Chillicothe Business College State Club Basketball Series in February 1940, going undefeated. From left to right are (first row) Opal Hessenflow (Utica) and Margaret Brenneman (Wheeling); (second row) D. Cobb, Mary Stamper (Utica), H. Autenrieth, M. Barnhill (Mooresville), and J. Cox; (third row) Imogene Rottler (sponsor), Ruth Souther, Mary O'Brien, M. Carter, H. James, D. Carlton (Chillicothe), and C. Welch (sponsor). The annual tournament packed the CBC gym each year. (Courtesy of Dorothy Switzer Spidle.)

Robert Wadlow—the "Tallest Man in the World" at 8 feet, 11 inches—was 22 years old when he visited Chillicothe on May 8, 1940, on a tour for Peters Shoe Company. He stayed overnight at the Leeper Hotel, where three beds were roped together for him. Using the front desk as a chair, he signed autographs for the several hundred people jamming the lobby. He also visited his friend Francis Walker down the street at Walker's Boot Shop. Wadlow wore size 37AA shoes, 18.5 inches long. His father provided transportation in the family DeSoto with the front passenger seat removed to make way for Robert's long legs. Two months later, Wadlow died in his sleep from an infection caused by a leg brace necessary for him to walk. (Both, courtesy of GRHSM.)

Dewey Day parades took place all over the country in the fall of 1899 to celebrate Adm. George Dewey's destruction of Spain's naval fleet in the Spanish-American War. This Chillicothe parade includes floats from Crown Roller Mills (Cherry and Ann Streets) and Ostrander and Wigely drugstore (northeast corner of the square) heading east on Webster Street. (Courtesy of Vicky England Elliott.)

The Doll Buggy Parade on October 13, 1916, in front of the Leeper Hotel, drew a huge crowd. Thousands of people were in town for the October 10–13 Farm Congress. The celebration was a combination agricultural seminar, county fair, and fall festival, with speakers, parades, stock shows, entertainment, and prizes for all ages. (Courtesy of Vicky England Elliott.)

Socrates England and his wife, Elizabeth (standing at left), along with other family members, take a break from hickory nutting across the river from the Wabash Railroad tracks west of Chillicothe. Harvesting was done in the fall. (Courtesy of Vicky England Elliott.)

Bear Lake, four miles southwest of Chillicothe, was a popular getaway for picnics and boat rides. A fishing club built a cabin there in 1902. Located on the original Highway 36 alongside the Grand River, the water level fluctuated, and once dried up completely in the 1930s but returned and was used for ice skating through the 1960s. (Courtesy of Vicky England Elliott.)

The Garrison School alumni basketball team of 1947 switched to baseball in 1948 as the Chillicothe Rockets and played through 1950 against Avalon, Utica, Wheeling, Chillicothe VFW, and other teams. The players pictured here are, from left to right, (first row) George Stewart, Don Williams, Raymond Kitchen, Charles Crain, Raymond Rex, and Herbert Mitchell; (second row) Chris Dandridge, Francis Midgyett, Leroy Green, Lester Williams, Joe Bentley, Edward Akers, and manager Henry Eubank. (Courtesy of GRHSM.)

The Ben Bolt opened in August 1949. John Irvin designed it as his dream theater for his hometown. It had state-of-the-art sound and projection equipment as well as a new type of screen. The marquee was one of the best in the country. The auditorium boasted two large murals with Frank Zimmerer's special black light technique. A large mural was also behind the water fountains. (Courtesy of LCL.)

ABOUT THE ORGANIZATION

The nonprofit Livingston County Preservation Society strives to preserve the stories of our past to share with the community and the future. Our projects include the Chillicothe Hall of Fame, century plaques, salvaging buildings, and writing history books.

DISCOVER THOUSANDS OF LOCAL HISTORY BOOKS
FEATURING MILLIONS OF VINTAGE IMAGES

Arcadia Publishing, the leading local history publisher in the United States, is committed to making history accessible and meaningful through publishing books that celebrate and preserve the heritage of America's people and places.

Find more books like this at
www.arcadiapublishing.com

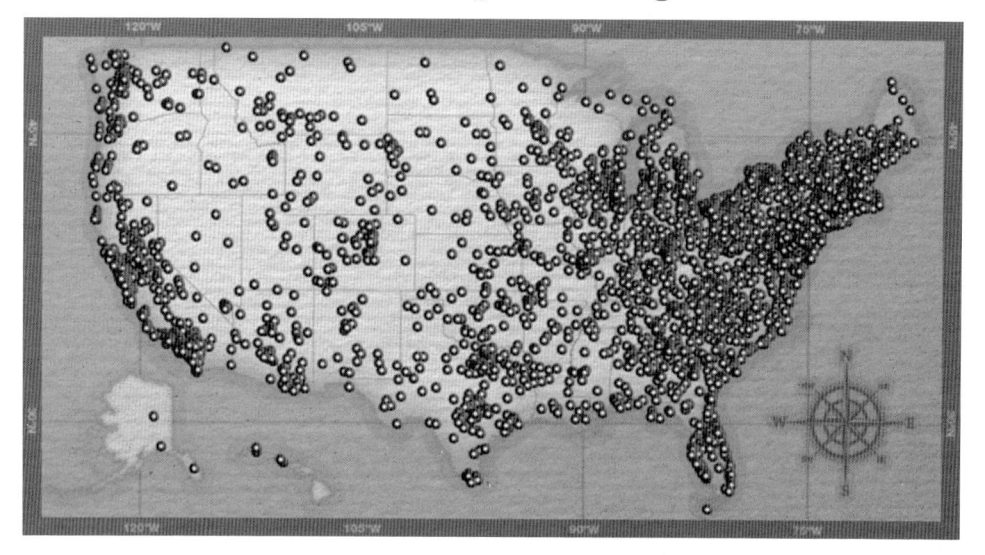

Search for your hometown history, your old stomping grounds, and even your favorite sports team.

Consistent with our mission to preserve history on a local level, this book was printed in South Carolina on American-made paper and manufactured entirely in the United States. Products carrying the accredited Forest Stewardship Council (FSC) label are printed on 100 percent FSC-certified paper.

MADE IN THE